A–Z

OF

BIRMINGHAM

PLACES - PEOPLE - HISTORY

Andrew Homer

AMBERLEY

First published 2020

Amberley Publishing
The Hill, Stroud, Gloucestershire, GL5 4EP
www.amberley-books.com

Copyright © Andrew Homer, 2020

The right of Andrew Homer to be identified as
the Author of this work has been asserted in
accordance with the Copyrights, Designs and
Patents Act 1988.

ISBN 978 1 4456 9736 9 (print)
ISBN 978 1 4456 9737 6 (ebook)

British Library Cataloguing in Publication Data.
A catalogue record for this book is available
from the British Library.

Typesetting by Aura Technology and Software
Services, India. Printed in Great Britain.

Contents

Introduction

Generally regarded as England's second city, especially by Brummies, any A–Z of Birmingham can only hope to touch upon some of the history, people and places associated with this area. Birmingham developed out of rural origins. There is evidence of Neolithic or early Bronze Age occupation at places such as Kingstanding and Sutton Park, the latter only relatively recently becoming part of Birmingham. The Romans had a fort at Metchley on Icknield (also Ryknild or Rycknield) Street, which passed through the region. Traditionally, the name is derived from the 'ham of the people of Beorma'. Robert K. Dent in his 1894 *The Making of Birmingham* writes about the seventh-century Anglo-Saxon Beormingas or Bermings and their home or ham, giving Birmingham its name. In 1086 the Domesday Book valued the rural manor of Birmingham at just 20 shillings. Its fortunes began to change when Peter de Birmingham obtained a royal charter from Henry II in 1166 to hold a market between the earlier St Martin's Church and his 'castle of Birmingham'. This later became a moated manor house, which survived as late as the early nineteenth century right where the Bullring is now. The town of Birmingham, later to become a city, grew from these modest beginnings. Birmingham, though, is not just the city. Expansion of the metropolitan borough of Birmingham, particularly in more recent years, has seen it encompass Royal Sutton Coldfield to the north-east and as far as the Lickey Hills to the south-west. Although bordering with the Black Country to the west, the two areas have steadfastly retained their own identities while still maintaining close links. The first canal in Birmingham was built by James Brindley to transport raw materials, especially coal, from the Black Country as Birmingham had scant mineral resources of its own, despite becoming known as the 'city of a thousand trades'.

While the contents of this book are arranged from A to Z, a number of common themes run through. There are the great movers and shakers of the Industrial Revolution such as Matthew Boulton and James Watt, social reformers and politicians such as Joseph Chamberlain, and the artists and artisans of the Arts and Crafts Movement. In any sphere you care to look – industry, social reform, politics, education, medicine and the arts – Birmingham has led the way. The Lunar Society and the Midlands Enlightenment flourished here, bringing together 'Lunarticks', the greatest scientists and free thinkers of their day. In the Second World War Birmingham's manufacturing capacity was vital to the war effort, not the least being Spitfire production during the Battle of Britain, albeit at a terrible cost during the Blitz.

Birmingham as a city seems to undergo almost constant development. From earlier social reforms to rid the city of slum dwellings to more modern

redevelopment schemes, the changing face of Birmingham has meant the loss of many fine buildings both old and not so old. Notable examples will be found within the pages of this book. Expect one or two surprises. Who would have thought that James Watt would have his own entry in the Guinness World Records or that a scientific breakthrough at the University of Birmingham helped avoid almost certain defeat during the Second World War? A surprising number of museums and visitor attractions, large and small, are featured, all helping to tell the story of Birmingham from A to Z.

Argent Centre and Pen Museum

The Argent Centre on Frederick Street in the Jewellery Quarter gives the impression of being a solid block of a building with corner towers. In fact, it was designed in an L shape by J. G. Bland with multiple narrow workshops, all built around a courtyard in order to allow light to enter from front and rear. Pevsner describes the building as being Lombardic Romanesque and featuring bright red, white and blue bricks. The towers originally had pyramid roofs. When completed in 1863 it was the pen works of William E. Wiley, a manufacturer of gold pens. Wiley had perfected the process of accurately slitting gold pen nibs using copper cutters. Part of the building was given over to housing luxurious leisure facilities including a Turkish Baths using recycled steam from the pen works.

The building was known as the Albert Works, possibly because it was opposite the Victoria Works of Joseph Gillott. Gillott had perfected the mass production of steel pen nibs by applying techniques he had learned in the cutlery- and buckle-making trades. At the height of the nineteenth-century trade it is estimated that Birmingham manufactured up to 75 per cent of the world's pens.

The unique Pen Museum, housed in the Argent Centre, celebrates the development of this important trade and its significance on worldwide literacy. Visitors to the museum can experience a range of writing implements and even have a go at making a pen nib using traditional techniques.

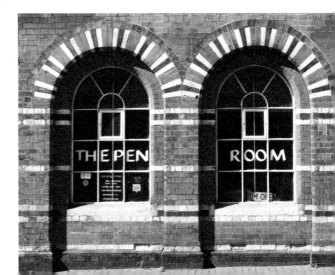

The Pen Museum.

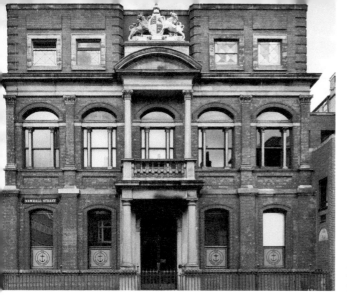

Former Assay Office, Newhall Street.

Assay Office

That Birmingham has an Assay Office at all is largely due to industrialist Matthew Boulton. Having expanded the Soho Manufactory from 1762 onwards, his small silverware items (known as toys) had to be sent over 70 miles to Chester for hallmarking. Boulton cited transport difficulties and, rather unfairly, incompetence at Chester in arguing for a Birmingham Assay Office. He called on powerful allies to lobby his case with Parliament together with representatives from Sheffield, who also wanted their own Assay Office. Boulton triumphed over stiff opposition from the London Goldsmiths' Company when the Hallmarking Act was passed by Parliament in 1773, enabling the new Assay Offices to be established.

While in London Boulton stayed at the Crown and Anchor in the Strand. A story has it that the toss of a coin determined that Sheffield's hallmark would be a crown (since changed to a rose) and Birmingham's would be an anchor, despite its distance from the sea. It could have been worse. He might have stayed at the Dog and Duck in Soho.

The first Birmingham Assay Office in 1773 consisted of three rooms above the King's Head on New Street but by 1815 had moved to Little Cannon Street. A further move in 1877 was to the now Grade II listed building on Newhall Street. In 2015 the busy Assay Office moved to Moreton Street, also in the Jewellery Quarter, and offers regular talks and tours of its superb silver collection.

Aston Hall

This magnificent Grade I listed Jacobean mansion was built between 1618 and 1635 by Sir Thomas Holte. It is hard to believe that Aston Hall was once a country seat given the development that has taken place around it. In 1642 Charles I stopped here on his way to the Battle of Edgehill while the Parliamentarians of Birmingham raided

his baggage train, resulting in later retribution by Prince Rupert. In 1643 Aston Hall was garrisoned by a small force of Royalist soldiers and found itself under siege by Parliamentarians from Coventry, almost certainly augmented by Colonel 'Tinker' Fox and his small Edgbaston garrison. Cannonball damage to the staircase is still visible.

In 1817 Aston Hall was bought by bankers Whitehead and Greenway, who leased it to James Watt's son, James Watt Jr, who lived there until his death in 1848. Aston Hall was then under threat during the 1850s when much of the park was redeveloped. In 1858 the Aston Hall and Park Company invited Queen Victoria to open the house and remaining grounds as a museum and park. The venture was not a financial success and in 1864 made history by being the first stately home to come into municipal ownership.

In 1897 Aston Villa Football Club moved onto Aston Lower Grounds, part of the Aston Hall Estate. The club had been formed in 1874 by members of Villa Cross Wesleyan Chapel cricket team who wanted a game to play in the winter. This was just one year before the formation of their great rivals the Small Heath Alliance, better known as Birmingham City Football Club. Aston Villa still play at the ground now known as Villa Park.

In the 1920s financial constrictions forced Birmingham City Council to choose between preserving nearby Perry Hall or Aston Hall. They chose Aston Hall, and it is now a popular historic tourist attraction.

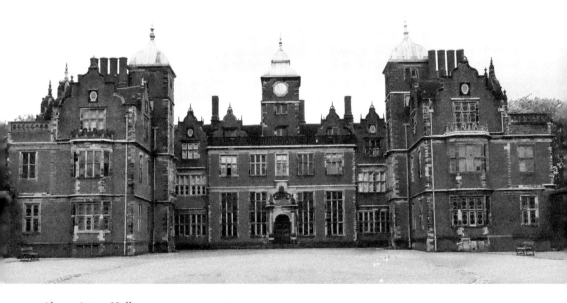

Above: Aston Hall.

Right: Aston Villa Football Grounds, 1904. (Photo by Birmingham Museums Trust, licensed under CC0)

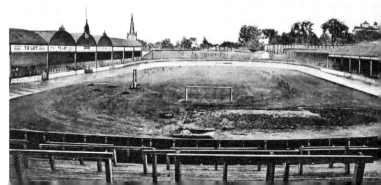

Back-to-Backs and Southside

By the 1840s back-to-back houses had become the norm for working-class Birmingham families. Built around a courtyard, they were generally three storeys high with a cellar and one room deep. This would be mirrored by the house to the rear. Families would share the outhouse or 'brewhouse', which would be used mainly for washing. Often families would share a tin bath – usually hung in the courtyard. A basic toilet in the yard would also be shared and emptied once a week by the night soil men. Court No. 15 is the last of many thousand such dwellings in Birmingham. They survived partly because the lower floors were still being used as shops when the majority of the back-to-backs were demolished. The court off Inge Street preserved by the National Trust was also used by home workers such as the glass eye maker and pearl button driller who lived and worked there. Displayed from the 1840s right through to the 1970s, the Birmingham back-to-backs are interpreted for visitors through prebooked guided tours.

While the housing was quite basic, in the later years there was no shortage of entertainment in the area now known as Southside. Immediately opposite is the Hippodrome Theatre, which was built on the site of former back-to-backs. Opened in 1899 as the Tower of Varieties and Circus with seating set 'in the round' it was not a success. Redesigned with a conventional auditorium and reopened as the

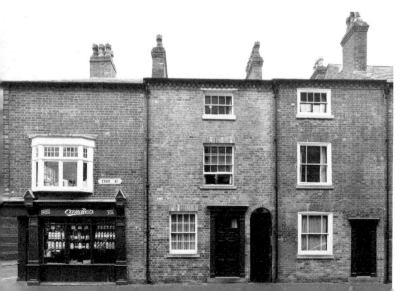

Birmingham back-to-backs.

Tivoli Theatre of Varieties in 1900, it became the Hippodrome Theatre of Varieties in 1903. Home stage to the Birmingham Royal Ballet, the Hippodrome is now one of the most popular theatres in the country.

A short walk away is the Alexandra Theatre or 'Alex', which opened in 1901 and was previously known as the Lyceum. After also failing in its first year, the theatre was purchased by the flamboyant Lester Collingwood. His melodramas and pantomimes appealed to public taste and the theatre became known as the 'People's Theatre'. The present 'Alex' was rebuilt in 1935.

On nearby Station Street is The Old Rep Theatre, which opened in 1913 under distinguished director Barry Jackson. It is Britain's oldest purpose-built repertory theatre still in use, although the Birmingham Repertory Company moved to a new theatre on Broad Street in 1971. In the same street is the Electric Cinema, which opened in 1909. This has the distinction of being the oldest working cinema in the country, although the interior has been put back to 1930s art deco rather than the original Edwardian decor. Nowadays, Southside also encompasses Chinatown and the Gay Village.

Big Brum, Council House, Museum and Art Gallery

All contained within one of Birmingham's most impressive buildings, the Renaissance-style palatial Council House was the first to be built in what became Victoria Square. A competition in 1870 to design new council buildings was won by local architect Yeoville Thomason and built between 1874 and 1879. In 1880 the Tangye Brothers, wealthy manufacturers, offered to purchase £10,000 worth of art providing the council built a new art gallery to house it. The Council House was extended into Chamberlain Square to accommodate the Gas Department, enabling the museum and art gallery to be built above it. The new Birmingham Museum and Art Gallery was formerly opened in 1885.

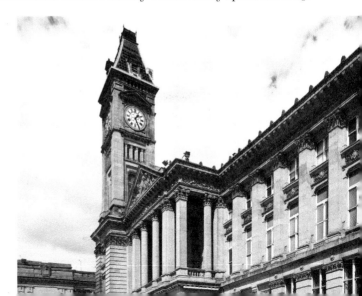

Council House clock tower known as 'Big Brum'.

Towering above is the impressive Council House clock tower, known affectionately as 'Big Brum'. The clock and bells, made by Gillet and Company of Croydon, were gifted to the city by Abraham Follett Osler, whose company supplied the magnificent glass fountain for the Great Exhibition of 1851.

At the height of militant suffragette action Bertha Ryland, a wealthy young Edgbaston suffragette and member of the Women's Social and Political Union (WSPU) entered the museum on 9 June 1914 and slashed George Romney's painting of Master Thornhill three times with a meat cleaver. A blue plaque commemorates her efforts to secure votes for women.

Birmingham Museum and Art Gallery houses a marvellous collection of Pre-Raphaelite art, a gallery dedicated to the Staffordshire Hoard and many other exhibits representing both Birmingham and world history.

Birmingham and Midland Institute

The Birmingham and Midland Institute (BMI) was founded in 1854 by an Act of Parliament for the 'Diffusion and Advancement of Science, Literature and Art among all Classes of Persons resident in Birmingham and Midland Counties'. It was a fusion of earlier educational institutions brought together through the vision of local lawyer and politician Arthur Ryland. The new adult education institution attracted the attention of some famous names including Charles Dickens who performed the first public readings of *A Christmas Carol* in December 1853 to raise funds for the new BMI. In 1869, Dickens would go on to become one of the institute's long line of distinguished presidents.

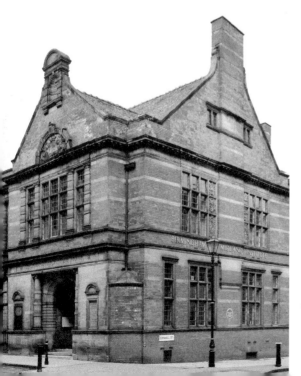

The Birmingham and Midland Institute.

The BMI was established in Paradise Street, but financial difficulties meant the new building wasn't properly completed until 1860. In 1955 the BMI merged with the original Birmingham Subscription Library established in 1779 by button manufacturer, John Lee. It moved to premises on Union Street in 1797. In 1781, Joseph Priestley catalogued the library using a system still used today. The library moved in 1899 to Margaret Street into a building designed by F. Barry Peacock of Cossins, Peacock and Bewlay. After losing the original Paradise Street premises in 1965 for a traffic scheme that never materialised, the BMI moved into the Margaret Street building, which was then extended in the early 1970s. The BMI continues to host a full programme of arts and science lectures, events and concerts for both members and the general public.

Birmingham School of Art

Birmingham School of Art was the country's first Municipal School of Art when it opened in 1885. It had its origins in the 1843 Birmingham Government School of Design. The Colmore estate provided the site, with the Tangye brothers donating nearly £11,000 and Birmingham benefactor Louisa Ryland also donating a similar amount towards the building costs.

Architect J. H. Chamberlain was heavily influenced by the writings of John Ruskin and designed the building in Ruskinian Venetian Gothic style shortly before his death in 1883. The ideals of the Arts and Crafts Movement were very much championed by the first headmaster, Edward R. Taylor. The design process was not complete until it was crafted in workshops using appropriate materials. This practical art and design

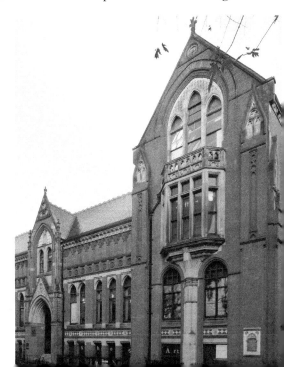

Birmingham School of Art.

training for both male and female students was very much influenced by luminaries such as William Morris and Birmingham artist Edward Burne-Jones. William Morris's daughter, May Morris, was an influential embroidery designer in her own right and she is known to have taught at the School of Art. Work in precious metals, jewellery and glass would find practical application especially in the workshops of the Jewellery Quarter, making nineteenth-century Birmingham a centre for the Arts and Crafts Movement.

In 1951 all jewellery and silversmithing was moved to the Birmingham School of Jewellery in Vittoria Street. The Birmingham School of Art is now part of Birmingham City University offering degree level courses to students in art and design.

Birmingham School of Jewellery

The date 4 November 1889 was a defining one in the history of the Jewellery Quarter. Successful classes in jewellery making at Ellen Road School had been set up by the Municipal School of Art, synonymous with the Arts and Crafts movement, and the Birmingham Jeweller's and Silversmiths' Association in 1888. Demand for places was such that a historic meeting took place in 1889 between the association and the foremost jewellery and silverware manufacturers to discuss the creation of a dedicated school of jewellery. The proposal was met with enthusiasm and the new School of Jewellery opened its doors to students on 18 September 1890. While initially concerned with craft classes for boys, it was also intended that courses for girls and women would be provided.

Birmingham School of Jewellery.

The building chosen for the school was on Vittoria Street. Originally a goldsmith's factory designed by J. G. Bland in 1865, the firm of Martin and Chamberlain was chosen to convert it for educational use. A third storey was added in 1906, designed by the partnership of Cossins, Peacock and Bewlay who in 1911 were given the commission to design a substantial red-brick extension, which now forms the main entrance. In 1951 it was decided to move all jewellery and silversmithing away from the School of Art in Margaret Street to the Vittoria Street school. In the early 1990s the school was further enlarged and now forms part of Birmingham City University. The School of Jewellery was unique in fusing the ethos of the Arts and Crafts Movement with the practical skills required of the jewellery trade.

Botanical Gardens

In 1829 the Birmingham Botanical and Horticultural Society was formed under the presidency of the Earl of Dartmouth to create a botanical garden. Increased interest in botany was partly due to developments in the transportation and raising of plants gathered from all over the world. The site selected was Holly Bank, an 18-acre gentleman's 'hobby farm' on the Calthorpe estate. Money was raised locally by selling 600 shares at £5 each. John Claudius Louden, celebrated garden designer and proprietor of *The Gardener's Magazine*, was invited to submit a design. The garden's first curator, David Cameron, was a regular contributor to Louden's magazine.

The garden was to be both ornamental and scientific, opening initially to society members in 1832. By 1844 it was decided that it would be too expensive to develop approximately one-third of the site and this was sold off to become Westbourne Road Leisure Gardens. Still in existence, they are a very rare surviving example of Victorian rented town gardens.

Prominent members of the society have included politicians Joseph Chamberlain, its president in 1876, and his son Neville Chamberlain who was treasurer from 1902 to 1909.

The Birmingham
Botanical Gardens.

Financial support was given by the Nettlefolds (later the 'N' in GKN) who also provided the Alpine Rock Garden in 1895.

Louden's original layout is largely unchanged apart from additional buildings such as glasshouses and the splendid 1873 bandstand. As well as major exotic plant collections, the Botanical Gardens are also an events venue and ever popular visitor attraction.

Boulton, Watt and Murdoch

The partnership of Matthew Boulton, James Watt and William Murdoch would power and light the Industrial Revolution. It began almost by chance when young James Watt, an instrument maker employed by the University of Glasgow, was given a broken Newcomen atmospheric steam engine to repair. While widely used to pump water out of mines since 1712, Watt was nevertheless surprised at the inefficiency of the engine. His great innovation of a separate steam condenser to improve efficiency came to him while strolling on Glasgow Green in 1765. Despite this great innovation, Watt was unable to make much progress with his ideas especially after losing his principal financial backer, John Roebuck. The great turning point came when James Watt moved to Birmingham in 1774 to join Matthew Boulton at Soho. The partnership they formed in 1775 was a perfect marriage of Watt's scientific and engineering brilliance with Boulton's entrepreneurial and manufacturing expertise. Although not a partner, crucial to the manufacture of the new steam engines was John 'Iron Mad' Wilkinson, whose boring bar for cannons proved ideal for boring cylinders with a previously unheard of accuracy.

In 1777 a young Scottish engineer, William Murdoch, walked 300 miles to Birmingham hopeful of a job with Boulton and Watt. Within a short space of time he was responsible for erecting steam engines for customers around the country. He introduced many improvements himself and is credited with designing the

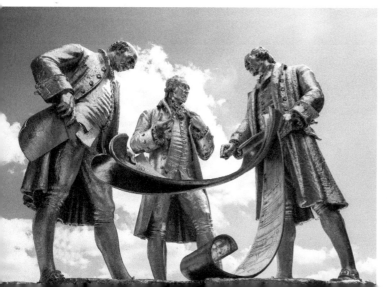

Statue of Boulton, Watt and Murdoch, the 'Golden boys', by William Bloye and Raymond Forbes-Kings. (Contributor: Alamy Stock Photos)

'sun and planet' gear (although it was patented by James Watt), which enabled horizontal or vertical motion to be turned into circular motion for driving machines. William Murdoch is also known for his pioneering work in the production of gas from coal. His gas lighting systems were sold by Boulton and Watt and emulated by many others. In 1810 the young man who walked from Scotland to work for Boulton and Watt became a full partner in the company.

In 1795 Boulton and Watt, together with their sons, set up the world's first dedicated steam engine works, the Soho Foundry, in nearby Smethwick. Thanks largely to Boulton, Watt and Murdoch steam engines would now power the machinery of the Industrial Revolution.

Bournville

The Bournville and Cadbury story started in 1824 when Bull Street grocer John Cadbury began making his own cocoa and drinking chocolate. By 1847 Cadbury had a factory in Bridge Street, which eventually proved too small for the expanding business. Now in the hands of sons George and Richard Cadbury they purchased a greenfield site for their vision of 'a factory in a garden'. This was to become Bournville. After purchasing the land in 1878 the new factory was in operation by 1879 together with the first sixteen homes for senior staff.

In 1893 George Cadbury and his wife Elizabeth purchased further land to develop their idea of a factory in a garden. A young architect was appointed, William Alexander Harvey, and he set about designing the Arts and Crafts-style buildings at Bournville.

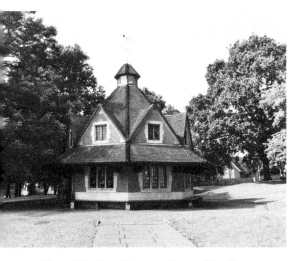

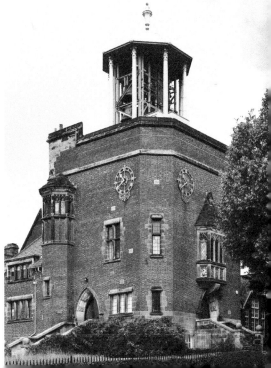

Above: The Rest House on Bournville village green.

Right: Carillon musical instrument in its own building.

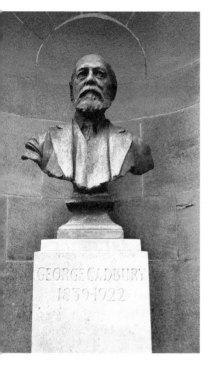

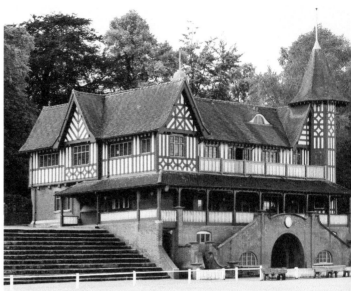

Above: Men's Recreation Grounds and Pavilion.

Left: Bust of George Cadbury at the Friends' Meeting House.

These were decent-sized houses with large gardens. Nothing like the cheap back-to-back and later tunnel-back houses that thousands of Birmingham workers and their families had to endure. The ideas realised in Bournville would influence the later Garden City Movement.

George Cadbury's ideas went further than just housing in that he intended that a third of the estate should be used as 'parks, recreation grounds and open space'. There were facilities for both men and women as on Bournville Lane where separate recreation grounds were laid opposite each other. Both George and Richard Cadbury were keen sportsmen and would often join their workers in a game of cricket.

The Cadbury family were committed Quakers and teetotallers – hence no public houses in Bournville. William Alexander Harvey designed the Quaker Meeting House built in 1905. A bronze bust of George Cadbury looks out over the green. Appropriately enough, the ashes of George and Elizabeth Cadbury lie beneath.

In 1906 George Cadbury gifted a Carillon to Bournville. This is a musical instrument contained within its own building. Originally with twenty-two cast bells, the number was increased to forty-eight in 1934. The instrument is played from a console using rounded levers known as batons.

The esteem in which George Cadbury and his wife were held was demonstrated in 1913 on the occasion of their silver wedding anniversary. Current and past employees of Cadbury worldwide paid for a rest house to be built on the green, which opened in 1914. It was intended as a place of shelter and rest in a busy world. It is now the Carillon shop and visitor centre.

Bullring and St Martin's Church

The beginnings of modern Birmingham can be traced back to 1166 when Peter de Birmingham obtained a charter from Henry II to hold a market at his 'castle of Birmingham' – where the Bullring is now. When Richard I succeeded to the throne Peter's son William reaffirmed the market status in 1189. This medieval marketplace was, and still is, at the heart of Birmingham. The exact date of the foundation of St Martin's Church is not known but is likely to have been late twelfth century and rebuilt in the thirteenth century. The present church is the result of a major rebuild in Victorian Gothic style by J. A. Chatwin in 1872–75. At that time, it still had its churchyard, which has been long since lost to urban development.

The first modern-day 'concrete jungle' brutalist style Bullring shopping centre was opened in 1964 but proved unpopular with both shops and shoppers. The present-day replacement Bullring was opened in 2003. Guarding the entrance to the west building is a sculpture that has become a symbol of Birmingham and named, appropriately enough, *The Guardian*. It is more popularly known as 'The Bull' and is a twice-life-size bronze sculpture of a Hereford bull, which has historic connections with the area. Lawrence Broderick's sculpture was commissioned to represent the past and future of the Bullring and Birmingham. In 2014 the *Independent* newspaper voted the much-photographed bull as one of the top ten works of public art in the world.

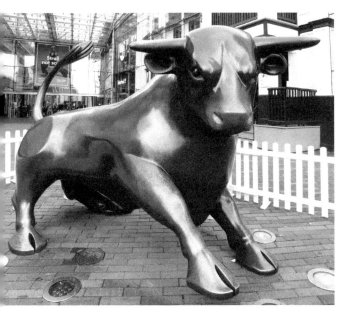

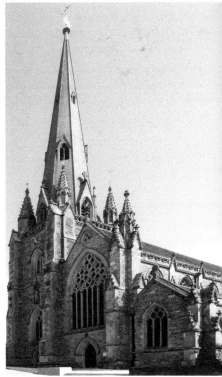

Above: The Bullring's famous bull.

Right: St Martin in the Bullring.

Castle Bromwich Aerodrome and Aircraft Factory

The Sentinel sculpture on Spitfire Island in Castle Vale is one of the few remaining clues to the vital role Castle Bromwich played in the Second World War. Another is Spitfire ML427, which once guarded the gate to Castle Bromwich Aerodrome, and is now on display at the Thinktank. The connection with aviation started in 1909 when Alfred P. Maxwell made the first powered flight in the Birmingham area. In 1911, Bentfield C. Hucks was giving passenger flights, and shortly after the Midland Aero Club was established. The airfield was requisitioned for the Royal Flying Corps as a flying school in 1914. Between the wars the aerodrome was used for both military and civil aviation purposes. It might have become Birmingham Airport if the Air Ministry had not objected to continued civil use, prompting the construction of Elmdon, which opened in 1939, and is now a major international airport.

With the onset of the Second World War Lord Nuffield (William Morris) was tasked with building the largest aircraft factory in Britain on land between Fort Dunlop and the airfield. Initially the factory had problems meeting Air Ministry targets until a team

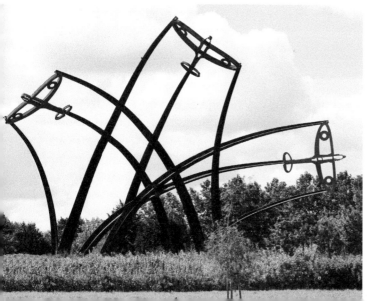

Commemorative *Sentinel* sculpture on Spitfire Island by Tim Tolkien, a descendent of J. R. R. Tolkien.

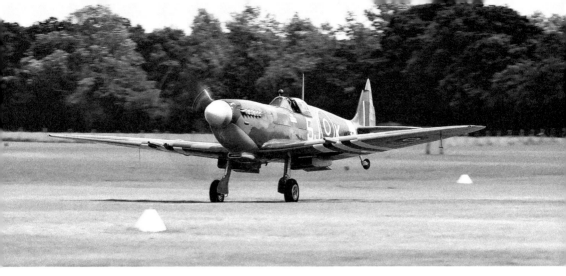

Castle Bromwich Spitfire MK356, Battle of Britain Memorial Flight. (Courtesy of Flyer1)

from Vickers-Armstrong was put in charge in 1940. Nearly 12,000 spitfires would be built here and from 1941 over 300 Avro Lancaster heavy bombers. Once completed planes would be towed to the airfield for testing before delivery to operational squadrons. Chief test pilot was the renowned Alex Henshaw who would often put on spectacular flying displays for visiting dignitaries such as Winston Churchill. Aircraft production ceased in 1945 and post war became a car factory, currently home to Jaguar Cars.

Castle Bromwich Aerodrome finally closed in 1958 and was demolished in 1960 to eventually became the Castle Vale Housing estate. Along with the loss of the airfield the site of the British Industries Fair was also lost. This had run from 1920 and was an immensely popular trade fair with an international reputation. Nevertheless, the foundations had been laid in Castle Bromwich for what is now the National Exhibition Centre.

Cathedral Church of St Chad

St Chad's was first Catholic cathedral to be built in Britain after the Reformation. Inspired by Bishop Thomas Walsh, it was designed in Gothic Revival style by Augustus Pugin and built between 1839 and 1841. It became a cathedral in 1850 after the Roman Catholic hierarchy of England and Wales was restored by Pope Pius IV. Pugin also designed a domestic Gothic style Bishop's House opposite in 1840–41, but sadly lost to an inner-city road scheme by 1960.

St Chad was a seventh-century Bishop of Mercia. His bones were rescued from a shrine at Lichfield Cathedral during the Reformation. After passing through a number of hands, the relics found their way to the new St Chad's Cathedral on the instruction of Pope Gregory XVI. Pugin based a new shrine on a description by the Venerable Bede. When St Chad's was consecrated on the 21 June 1841 the relics were placed in the shrine above the high alter. In 1995 the bones were examined by the University of Oxford Archaeology Unit. It was concluded that at least one, and possibly three, of the relics could indeed be the bones of St Chad.

St Chad's Cathedral.

On 22 November 1940 an incendiary device crashed through the roof during an air raid and could have destroyed the cathedral. It fell on some central heating pipes, which burst and put out the flames. The spot is marked by a replacement roof panel bearing the words 'Deo Gratias' (Thanks to God).

Cathedral Church of St Philip

As Birmingham was rapidly expanding in the eighteenth century, St Martin's could no longer cope. The Phillips family gave the land and commissioners appointed by the Bishop of Lichfield oversaw the building of a new church to a design by Thomas Archer. Archer had done the Grand Tour of Europe, and in particular studied Italian baroque architecture. His Grade I listed St Philip's Church is one of the finest examples of English baroque architecture. Building started in 1709 and the church was consecrated in 1715 as St Philip's in recognition of the Phillips family, but the tower wasn't completed until 1725.

Yeovil Thomason redecorated the interior in 1871, but between 1883 and 1884 J. A. Chatwin extended the chancel, providing space to house an organ and space for the superb stained-glass windows. Emma Villiers-Wilkes donated the money and Chatwin obtained the services of Edward Burn-Jones to design the windows, which were made by William Morris and Company. Miss Villiers-Wilkes insisted that there should be no oxen in any windows she was paying for, and there aren't! Fortunately, the windows had already been put into safe storage when an incendiary caused severe damage in October 1940. The damage had been put right by 1948.

In 1905, with the formation of the new diocese of Birmingham, St Philip's was made a cathedral. In terms of size it is one of the country's smallest. In terms of art and architecture, it is one of the finest.

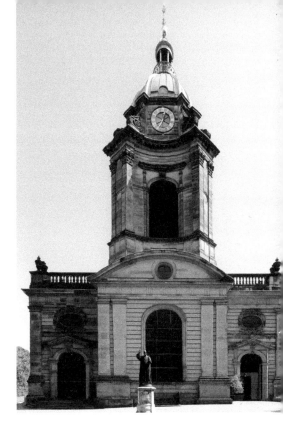

St Philip's Cathedral.

Central Library

Birmingham has had no less than four 'central' libraries. The first, designed by Martin and Chamberlain, opened in 1865 following adoption of the 1850 Public (free) Libraries Act in 1860. In January 1879 a fire broke out behind a petition, destroying most of the building. It was replaced by a new library designed by J. H. Chamberlain in Lombardic Renaissance style with a magnificent high-ceilinged reading room. Despite efforts to save it, this library was demolished in 1974 shortly after its replacement had already opened.

The new Central Library was nothing if not controversial. Birmingham architect John Madin created a striking example of Brutalist architecture with his 'inverted ziggurat' design. Pevsner's *Architectural Guide* described it as being, 'The finest example of the Brutalist aesthetic in Birmingham' and a civic building of 'European importance'. Not everyone agreed. Prince Charles commented that it looked like 'a place where books are incinerated, not kept'. City planners referred to it as a 'concrete monstrosity'. This was not entirely fair to Madin as his original plans called for travertine and later Portland stone cladding to compliment nearby civic buildings. Looking to cut costs the city architect specified concrete cladding instead. Not only that, Madin's plans included water features, trees and planted areas around the building. None of this materialised. Despite efforts to get the building listed and a vigorous campaign to save it, the library was demolished in 2016.

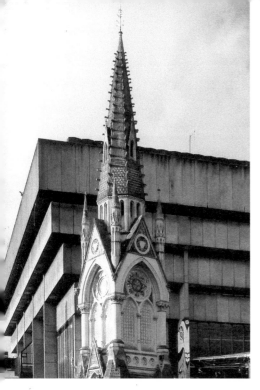

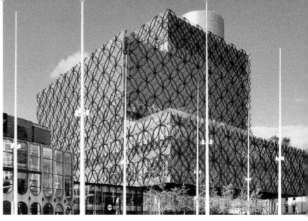

Above: Library of Birmingham by Mecanoo.

Left: Former Central Library and Joseph Chamberlain memorial.

The new Library of Birmingham opened in September 2013 and is currently the largest in Europe. It was designed by Francine Houben of Dutch architectural firm Mecanoo. She described the building as very much a 'public space' with rooftop gardens, outdoor amphitheatre and unparalleled views across the city.

Coffin Works

Brothers Alfred and Edwin Newman established a foundry business in 1882 producing mainly brass cabinet fittings in Nova Scotia Street. The year 1894 saw a move to the premises in Fleet Street in the Jewellery Quarter, built in 1892. The brothers decided to specialise in a trade with plenty of demand and became Coffin Furniture Manufacturers. As well as producing the finest quality brass fittings for coffins such as handles, breast plates and associated items they also diversified into producing shrouds and robes.

The quality of Newman Brothers coffin furniture was second to none and was used for the funerals of statesman, the nobility and royalty. King George V, the Queen Mother, Princess Diana, Winston Churchill and Birmingham's own Joseph Chamberlain were among those laid to rest in coffins adorned with Newman Brothers brass fittings.

The company continued in the Newman family up until 1952 when Horace Newman, the last member of the family to run the company, passed away. Joyce Green had joined the company in 1949 as office secretary but by 1989 had acquired the company herself. Steeped as it was in traditional practices, the company eventually lost out to competition and ceased trading in 1998. It was finally wound up in 1999.

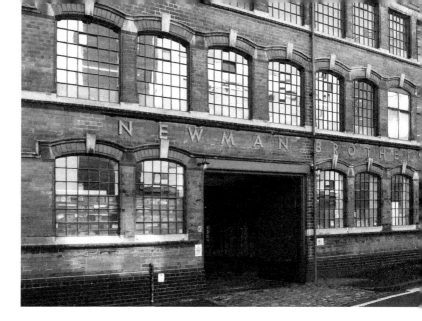

Newman Brothers 'Coffin Works'.

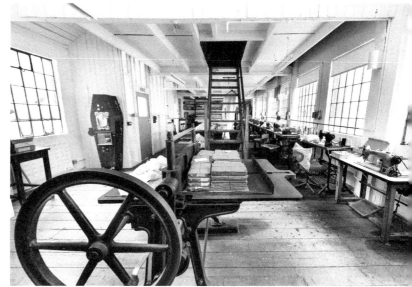

The Shroud Room, also known as the Sewing Room. (Copyright 'Coffin Works' Collection)

Joyce's dream was that the Coffin Works would become a museum and after a great deal of effort over many years involving a variety of organisations and individuals that dream has come to fruition. The Coffin Works Museum now runs fascinating guided tours of this unique and carefully preserved facet of Birmingham's history.

Curzon Street Station

Curzon Street station was Birmingham's first railway terminus when it opened in 1838. The architect was Philip Hardwick for Robert Stephenson's railway connecting to London where he had also designed the complimentary Doric Arch at Euston Square.

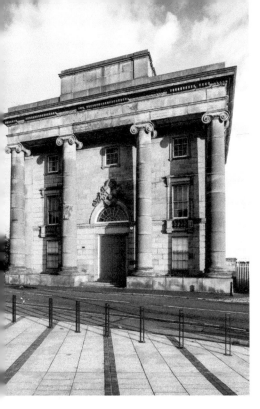

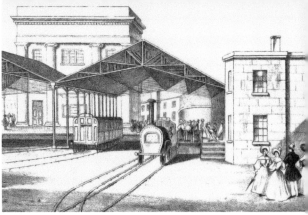

Above: Curzon Street station, 1838. (Photo by Birmingham Museums Trust, licensed under CC0)

Left: Curzon Street station. (Copyright Historic England Archive)

A year later the Grand Junction Railway also reached Curzon Street and passengers could swap platforms to travel onwards to Liverpool and Manchester. In 1846 both companies merged and, along with the Manchester and Birmingham Railway, formed the London and North Western Railway (LNWR).

The line to London took four years to construct and employed over 20,000 men between 1834 and 1838. When it opened in 1838 it was the first direct rail link between Birmingham and London, but comfort was non-existent for some passengers on the over five-hour journey. It was only as a result of the 1844 Railway Regulation Act that third-class passengers had to be supplied with seats and protection from the weather. Consequently, due to the exposed nature of the journeys, and particularly through tunnels, it was common for passengers to wear eye protection of glass or gauze.

Because of its distance from the centre of Birmingham, Curzon Street closed to regular passengers in 1854 and was then mainly goods only until closed in 1966. The replacement passenger station was New Street station, which opened in 1854. The Grade I listed Curzon Street building and the area around it is to be revived as the Birmingham station of the planned new HS2 high-speed rail link.

Custard Factory

Household names from Birmingham include Typhoo Tea (originally Typhoo Tipps), launched by grocer John Sumner in 1903. Typhoo is based on the Chinese word for

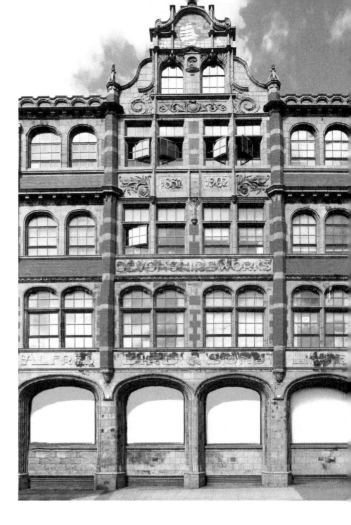

Bird's Custard factory.

doctor and was marketed as a healthy brand of tea. His great innovation was to sell the tea pre-packaged rather than loose.

Another was Bird's Custard. In 1837 Alfred Bird, a young 'experimental' chemist as he described himself, opened his first shop in Bell Street Birmingham. He was to invent two products that would make his name and fortune. The first was Bird's Fermenting Powder, now known as baking powder, and the second was an eggless custard powder. Alfred's wife, Elizabeth, suffered from digestive ailments and was intolerant to both yeast and eggs, but she loved custard. Bird's Custard was a tremendous success. After Alfred Bird died in 1878 his son, Alfred Frederick Bird, went on to greatly expand the company, eventually opening a new factory in Gibb Street, Digbeth. In 1902, Devonshire House was completed and inscribed as the 'Devonshire Works of Alfred Bird and Sons'. Upwards of a thousand people were employed on the site until eventual relocation to Banbury. A blue plaque in Gibb Street records that production ended here in 1963.

The redeveloped Custard Factory as it is now known has become a vibrant centre for creativity and digital enterprise together with shops, cafés, bars and restaurants set within acres of restored former factory buildings.

(Fort) Dunlop

An unmistakable sight for motorists on the M6 at Erdington is the massive Fort Dunlop building. Its history goes back to 1887 when John Boyd Dunlop, a veterinary surgeon, developed a basic pneumatic tyre to improve the ride of his son's tricycle. He patented his idea in 1888, not knowing that Robert Thomson had already taken out a similar patent in 1845. Together with Harvey du Cros he founded the Pneumatic Tyre and Booth's Cycle Agency Ltd in Dublin. In 1889 the Dunlop name was first used by a supplier to the parent company. Various name changes followed and Dunlop himself joined a rival company in 1894. By 1896 du Cross had acquired the patents, which meant Dunlop never properly benefitted. In 1901 the Birmingham Rubber Tyre Manufacturing Company was acquired by its financier, Harvey du Cros and renamed Dunlop Rubber Company Limited. By this time there was no connection with Dunlop himself and the founder company was purchased in 1912.

Having obtained the Erdington site, increased demand during the First World War meant that the factory was greatly enlarged. The building now known as Fort Dunlop was built as a storage facility designed by mill architect Sidney Stott with W. W. Gibbings and completed in the 1920s. Foreign competition led to the closure of Fort Dunlop in the 1980s, having at one time been one of the world's biggest manufacturer of tyres.

The iconic Fort Dunlop was fully refurbished in 2006 by Urban Splash and is now a unique office, shops, leisure and hotel complex.

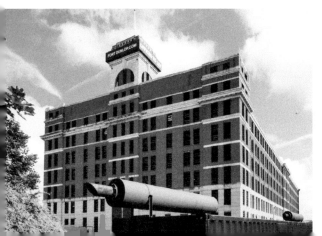

Fort Dunlop.

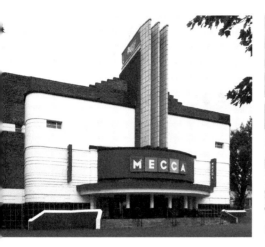 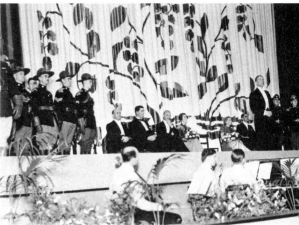

Above left: Grade II listed former Kingstanding Odeon.

Above right: Kingstanding Odeon opening ceremony in 1935 with Oscar Deutsch seated on the left. (Copyright Historic England Archive)

Deutsch, Oscar

Oscar Deutsch was born in 1893 at Balsall Heath, the son of a Jewish scrap merchant. He built his first cinema, the Picture House, at Brierley Hill in 1928. Always interested in new technology, he saw the potential of the new 'talking pictures' and converted it to sound in 1930. Another Picture House was planned for Perry Barr in 1930 but the name was already in use. Associate Mel Mindelsohn had seen the name Odeon in Tunis which coincidentally contained Oscar's initials. Later on, the Odeon name would acquire the acronym 'Oscar Deutsch Entertains Our Nation'.

The Odeon chain proper began in 1933 and very rapid expansion followed. While building new cinemas, existing cinemas would be bought up and renamed. Oscar Deutsch was the public face of Odeon, but he had a talented team around him as did Birmingham architect Harry Weedon. Together they would create the definitive Odeon style, first realised in 1935 with the Kingstanding Odeon, designed by J. Cecil Clavering of the Harry Weedon office.

Kingstanding embodied most of what became Odeon style. A modernist design featuring rounded corners with fins or towers and light-coloured, glazed, terracotta on the exterior. The curved brickwork conceals separate staircases for the projectionists. Oscar's wife Lily would often advise on the art deco interiors. Recognised as being one of the finest surviving modernist cinemas, Kingstanding Odeon was Grade II listed in 1980 and survives as a bingo hall.

Oscar Deutsch died of cancer in 1941, aged just forty-eight, and Lily subsequently sold her shares in Odeon to J. Arthur Rank.

Edgbaston Hall

During the English Civil War Edgbaston Hall was seized for the Parliamentarians and housed a garrison commanded by Colonel 'Tinker' Fox. Royalist propaganda of the day labelled him as a low-born 'jovial tinker' from Walsall. Tinker Fox was almost certainly involved in the attack and subsequent surrender of Aston Hall in 1643, thereby removing any threat to his garrison at Edgbaston. He was particularly adept at executing guerrilla-type raids on townships. His raid on Bewdley is a good example where there was never any intention to hold the town, merely to loot and take prisoners. Fox managed to bluff his way into the town masquerading as a lost Royalist troop of Prince Rupert's men.

The present Grade II listed Edgbaston Hall was built in 1717 when Sir Richard Gough rebuilt the earlier building which was burnt down in 1688. His grandson Sir Henry Gough had the park improved by Lancelot Capability Brown before marrying Barbara Calthorpe. The wealthy and influential Gough-Calthorpe family moved out in 1783. In 1786 it was leased by Lunar Society member Dr William Withering who is famed for discovering Digitalis, derived from foxgloves and used in the treatment of certain heart conditions.

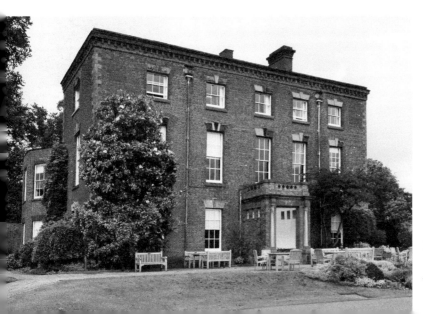

Edgbaston Hall.

In 1936, the Calthorpe Estate leased the hall and park to Edgbaston Golf Club. By 1937 the renowned course designed by H. S. Colt had been established in the park and flourishes today as a private member club and events venue. Dr Withering's foxgloves still grow freely by the stream in the grounds.

Edgbaston Stadium

Edgbaston Stadium is renowned for world-class cricket and is home to Warwickshire County Cricket Club. Ironically, it is no longer in Warwickshire, but was when the Calthorpe estate set about developing Edgbaston as an

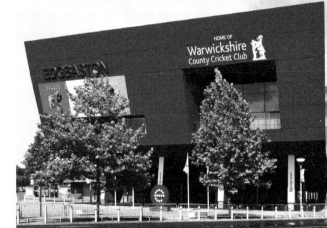

Right: Edgbaston Stadium, nicknamed the 'Fortress'.

Below: Edgbaston Cricket Ground in 1895. (Contributor: Alamy Stock Photos)

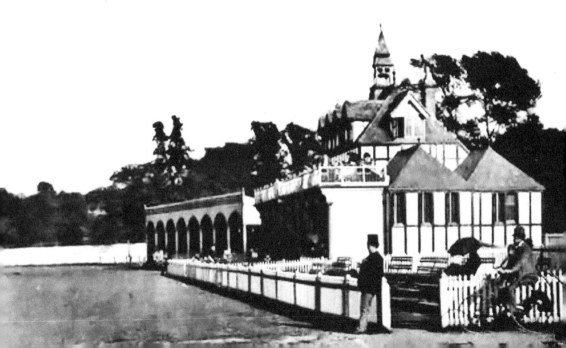

exclusive suburb of Birmingham in the nineteenth century. The Warwickshire County Cricket Club had been formed in 1882 but it had no home ground. The gentlemanly game of cricket suited Calthorpe Estate's vision for the leafy suburb. The club favoured Wycliffe Ground on the Pershore Road but Calthorpe estate was keen to develop some 'rough grazing land' on the banks of the River Rea. The Warwickshire club secretary William Ansell (of Ansells Brewery) approved of the site on the grounds that it was within easy walking distance of New Street station and accessible to Birmingham's growing population. The 12-acre site was leased for £5 per acre over a twenty-one-year period. The land was drained and fenced off for £1,250 and a wooden pavilion built.

The first match, against Marylebone Cricket Club, was played at the new ground in 1886. Later that year, Warwickshire played Australia in front of a 6,000-strong crowd. The first test match in the Ashes series was in 1902 and the ground went from strength to strength. Edgbaston stadium has been extensively developed in the post war years to become the world-class ground it is now. Behind the scenes tours offer a fascinating glimpse into this historic sporting venue.

Edward Burne-Jones

Edward Burne-Jones was born on Bennetts Hill, Birmingham, in 1833. His father was a framer and gilder. His mother, Elizabeth, died just a few days after his birth. After attending King Edward's School, he took drawing classes at the Birmingham Government School of Design, a precursor to the Birmingham School of Art. In preparation for a career in the church, Burne-Jones went to Oxford where he met the man who would become his lifelong friend, William Morris. They were both active in the Birmingham 'Set', later known as the 'Brotherhood' at Oxford, and under their influence the group became interested in the writings of John Ruskin and medieval art and architecture. Burne-Jones was encouraged and mentored by Pre-Raphaelite artist Dante Gabriel Rossetti to pursue a future not in the church but in art and design. Inspiration would come from medieval art, religion and myths such as the legend of King Arthur. Edward Burne-Jones and William Morris were pioneers of the influential Arts and Crafts Movement, which rejected Victorian industrialisation in favour of traditional crafts.

Between 1885 and 1891 Burne-Jones was commissioned to create a series of remarkable stained-glass windows for St Philip's Church, which became Birmingham Cathedral in 1905. Executed in glass by William Morris and Company, the magnificent windows depict the Ascension, Nativity, Crucifixion and the Last Judgement. Sir Edward Burne-Jones, as he had now become, died in 1898. Work by Edward Burne-Jones can be seen in the Pre-Raphaelite galleries at Birmingham Museum and Art Gallery.

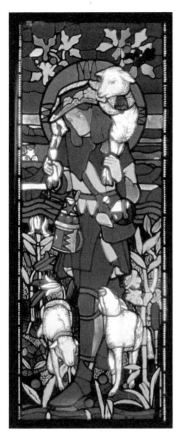 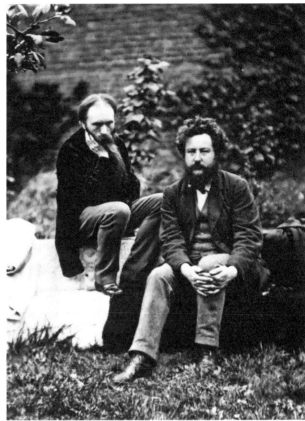

Above left: The Good Shepherd, 1861. (Photo by Birmingham Museums Trust, licensed under CCo)

Above right: Edward Burne-Jones on the left with William Morris. (Contributor: Alamy Stock Photos)

Elan Valley Water Scheme

The scourge of Victorian Britain was contaminated drinking water, carrying with it diseases such as typhoid and cholera. Birmingham City Council, under Joseph Chamberlain, needed to find a clean water supply capable of satisfying the needs of the growing city. Engineer James Mansergh came up with an ingenious plan to dam the Elan and Claerwen Valleys in Wales. Because the valleys were situated higher than Birmingham, Mansergh's idea was to have the water delivered by pipeline using gravity alone. An Act of Parliament for the compulsory purchase of the valleys was passed in 1892. Needless to say, there was opposition and not least from within Wales itself, but by this time Joseph Chamberlain, now MP for Birmingham, was in a position to successfully champion the Birmingham Corporation Water Act in Parliament.

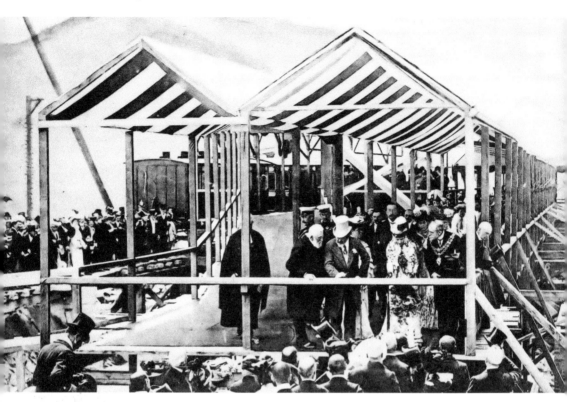

King Edward VII and Queen Alexandra opening the Elan Valley water scheme in 1904. (Photo by Birmingham Museums Trust, licensed under CC0)

Construction started in 1893. People were moved out of their homes, without compensation unless they were landowners, and buildings demolished to make way for the dams. A village for workers and their families was constructed as was a railway for transportation. As well as the dams a 73-mile system of pipes, bridges and tunnels was constructed to carry the water at approximately 2 miles per hour to Frankley Reservoir on the outskirts of Birmingham. The first phase of the scheme was opened in 1904 by King Edward VII and Queen Alexandra. Additional water storage was provided by Bartley Reservoir from 1930 and the massive Claerwen Dam was opened by Queen Elizabeth II in 1952.

(J. W.) Evans Silver Factory

Tucked away in Albion Street is another of the Jewellery Quarter's most remarkable survivors of a lost manufacturing world. Founded in 1881 by Jenkin Evans, the successful silverware business developed in workshops behind four terraced houses. In a highly skilled trade, they produced small silver items for personal use known as 'toys' and high-quality silver tableware. The industry revolved around two related processes,

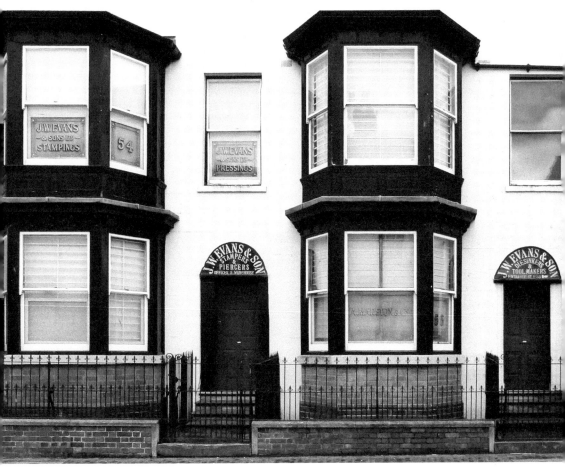

J. W. Evans silver factory.

die-sinking and drop-stamping. The preserved factory contains many thousands of steel dies, most of which had been painstakingly cut by hand. Once made the dies could stamp out many thousands of precision items. The drop-stamper would be responsible for stamping these out from sheets of silver using a powered hammer, another highly skilled job. The skills involved in these and other processes would take many years to master.

The company flourished up until the First World War employing men, women and children. Then began a slow but steady decline fuelled by foreign imports, modern production techniques and a reduced market for silverware, which has led to near extinction of the traditional skills. J. W. Evans had ceased trading by 2008 and was acquired by English Heritage.

Dies, stamping machines, presses, tools, finished and unfinished silver products all remain in place after 127 years of manufacturing. Guided tours of this historic workshop can now be booked through English Heritage.

First Birmingham Canal

The early eighteenth century saw Birmingham establishing itself in manufacturing and trade. The lack of raw materials such as coal and iron, the absence of navigable rivers, and inadequate road links were problems in desperate need of a solution. That solution presented itself when James Brindley was engaged by the Duke of Bridgewater to cut a canal from his coal mines in Worsley to textile manufacturing Manchester. Opened in 1761, the success of this and similar projects was not lost on the likes of industrialists such as Matthew Boulton. A meeting took place at the Swan in Birmingham in January 1767 when it was agreed that a navigable 'cut' be surveyed by James Brindley. By June of 1767 Brindley's survey had been completed. An Act of Parliament subsequently approved a canal from Birmingham to navigate through the coalfields of the Black Country and on to the Staffordshire and Worcestershire canal at Aldersley, north of Wolverhampton.

Work carried on apace and the first shipment of coal reached Birmingham by canal in November 1769. Birmingham's manufacturing and trading future was assured. By 1772 the final section of canal to Aldersley had been completed requiring the construction of twenty locks. Fully opening on 21st September 1772, the new canal

Old Wharf terminus of the Birmingham Canal and Paradise Street offices. (Photo by Birmingham Museums Trust, licensed under CC0)

revolutionised the import of raw materials and the export of finished goods. James Brindley, the 'father of the English canals', died a few days later after contracting a chill while surveying another of his canals.

Floozie in the Jacuzzi

In 1992 Birmingham City Council commissioned Dhruva Mistry to design sculptures to feature in a revamped Victoria Square, officially reopened by the late Princess Diana in May 1993. Born in India, Mistry had studied at the University of Baroda before obtaining a scholarship to study at the Royal College of Art in London.

Dhruva Mistry's composition, *The River*, featured one of the largest fountains in Europe with a water flow of 3,000 gallons per minute. Four sets of statues complete the whole piece. By far the biggest is a naked female figure representing life force and weighing in at 1.75 tonnes. She is accompanied by two smaller figures at the base of the fountain entitled Youth. Two Sphinx-like creatures are the Guardians and the work is completed by two obelisks of unknown meaning now used as lamp standards. *The River* was very soon nicknamed 'the Floozie in the Jacuzzi'.

The rim of the top pool has a quotation from T. S. Eliot's poem 'Burnt Norton', carved by Bettina Furnée:

> And the pool was filled with water out of sunlight,
> And the lotos rose, quietly, quietly,
> The surface glittered out of heart of light,
> And they were behind us, reflected in the pool.
> Then a cloud passed, and the pool was empty.

The last line proved to be particularly prophetic as since 2013 no water has flowed in The River due to persistent leaks. The pool is currently filled with plants, although there are plans for the River to flow once more.

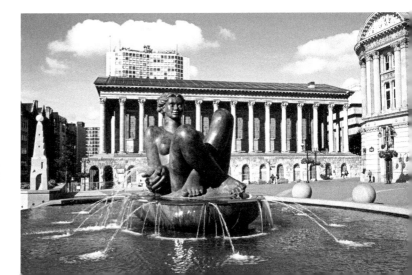

The River, nicknamed 'Floozie in the Jacuzzi'. (Contributor: Alamy Stock Photos)

Gas Street Basin

The name Gas Street may be uninspiring, but it is apt. One of the first streets in Birmingham to be lit by gas, it also has what is possibly the world's oldest surviving retort house where gas was extracted from coal. Dating back to 1819, the Birmingham Gas, Light and Coke Company supplied town gas for local street lighting and factories. The historic 1822 building was nearly lost until its significance was realised and it was given a Grade II listing in 1993. The building is now home to St Luke's Gas Street Church. The gas works would have had coal delivered by canal from the Gas Street Basin below.

At Gas Street Basin the Birmingham Canal met the later Worcester and Birmingham Canal. Competition between the two companies was intense and the 1791 Act of Parliament approving the newer canal contained a clause to keep them apart. A physical barrier, called the Worcester Bar, was installed. This meant goods passing through had to be unloaded from one barge and manually transferred to another. This unsatisfactory situation was resolved in 1815 when the Birmingham Canal Company agreed to the creation of a stop lock. This was a short length of canal with a lock

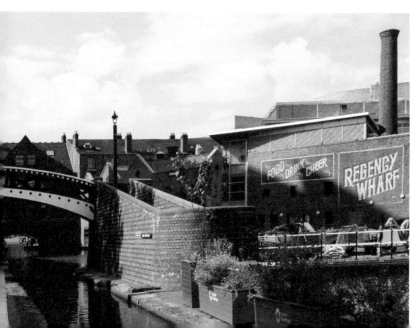

Gas Street Basin and the Worcester Bar.

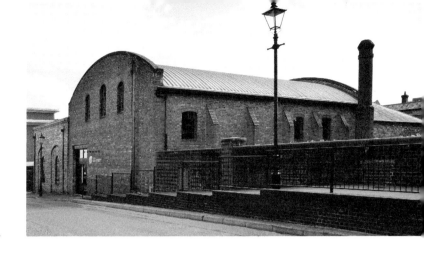

Former Gas Retort
House in Gas Street.

at each end to contain barges while the tolls were assessed before allowing passage
through to the other canal. Gas Street Basin is now a popular leisure attraction with
pubs, cafés and restaurants all set around narrowboat moorings and canal history.

Golden Lion Inn

The Old Crown public house at Deritend is often cited as the only remaining Tudor
timber-framed secular building in the city, but there is another one. The Golden Lion
Inn, also originally from Deritend, is no longer in situ as it was moved to Cannon Hill
Park in an early twentieth-century effort to preserve it.

Built circa 1520, the building most likely housed clergy from the nearby Church of
St John the Baptist and served as the Guild School. A former pupil of the school was
almost certainly John Rogers who was born in Deritend around 1500. After forming
an association with William Tyndale, Rogers worked on an English translation of the
Bible. An early Protestant martyr, he was burned at the stake in 1555 during the reign
of 'Bloody' Queen Mary I.

Mainly through the efforts of the Birmingham Archaeological Society, the Golden
Lion was saved from demolition and moved to Cannon Hill Park in 1911. It was
intended to serve as a refreshment and cricket pavilion. Historic England describes

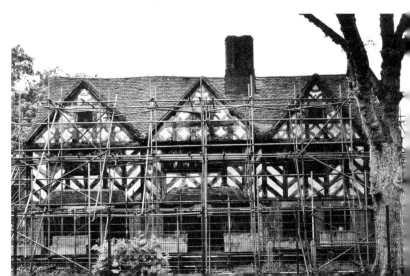

The Golden Lion in
Cannon Hill Park.

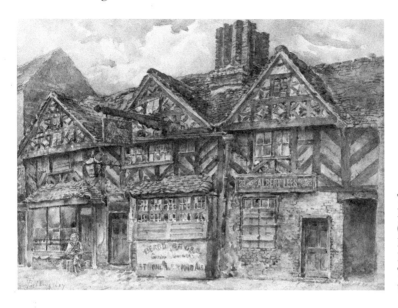

The Golden Lion Inn, Deritend. (Photo by Birmingham Museums Trust, licensed under CC0)

the Grade II listed building as being a 'memorial', presumably to Birmingham's mainly lost Tudor heritage.

Presently, the Golden Lion Inn is in a poor state of repair. A voluntary group, the Friends of the Golden Lion, are working hard towards restoring this historic building to its former glory and giving it a purpose once again.

Grazebrook Engine

Motorists driving around the busy Dartmouth Circus may be left wondering what the massive structure exhibited in the centre is. This is the Grazebrook Engine. Built to a design by James Watt in 1817, the giant beam engine was used as a blowing engine to force air into blast furnaces to achieve the temperatures required to smelt iron.

Widely regarded as the largest steam engine in the Black Country, it was used at the Netherton ironworks of M. & W. Grazebrook. The engine supplied air at approximately 5 Ibs per square inch to two blast furnaces with a blowing cylinder or 'tub' of 7 ft in diameter. The beam, weighing in at 10 tons, is 28 ft in length. A 42-inch steam cylinder with a stroke of 8 ft produced between 12 and 16 strokes per minute. Six Lancashire boilers provided the steam to power the mighty engine. The flexible lime mortar used in the brickwork of the engine shed avoided it being shaken apart!

The Grazebrook Engine was in regular use until 1912. It was then kept in good working order as a backup blowing engine right up until 1964 when it was dismantled and relocated to Dartmouth Circus by the Birmingham Science Museum. For a closer look, the engine can be accessed via a subway under Dartmouth Circus. At one time it was intended that the engine would be operated hydraulically but this was deemed to be just too distracting for passing motorists!

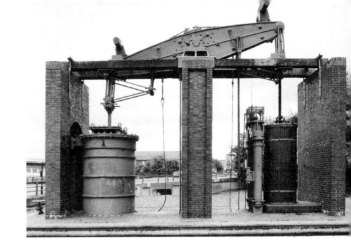

The Grazebrook Engine on Dartmouth Circus.

Gun Quarter and the Gun Barrel Proof House

Originating in the seventeenth century with the manufacture of muskets, the gun trade developed rapidly particularly with government orders for the military. In the nineteenth century the Napoleonic Wars and the American Civil War generated lucrative orders for the gunsmiths who by now were mainly centred in an area bounded by Steelhouse Lane, Shadwell Street and Loveday Street. This was the 'Gun Quarter'. In 1861 a number of gunsmiths in the Birmingham Small Arms Trade Association (founded in 1854) formed the Birmingham Small Arms Company to take advantage of mechanisation. They purchased land in Small Heath and BSA was born.

Up until 1813 proofing of firearms was carried out in private proof houses run by gunmakers themselves or sent to London for independent testing. An Act of Parliament in 1813, requested by reputable Birmingham gunmakers, allowed the Gun Barrel Proof House to be established in Banbury Street. Then as now the Proof House is governed by a Board of Guardians consisting of gunmakers, magistrates and councillors and is managed by a Proof Master. Firearms are inspected and tested under stress by firing a 'proof' charge through the barrel. After over 200 years, the Grade II listed building designed by John Horton is still a working Proof House, even though much of Birmingham's gun trade has now disappeared. The Gun Barrel Proof House has its own museum and tours can be arranged by appointment.

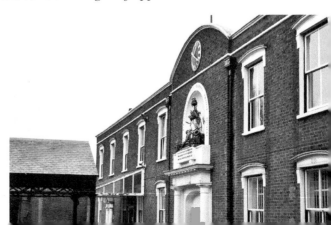

Birmingham Gun Barrel Proof House. (Courtesy of Ashley Dace)

Hall of Memory

Following the First World War a competition was held in 1920 to design a war memorial to the 12,320 people of Birmingham who served and fell. Birmingham-based S. N. Cooke and W. Norman Twist were chosen as winners by respected architect Sir Reginald Blomfield. Their design was for the Hall of Memory. Also included was a Portland stone colonnade, a series of connected columns, to stand opposite the hall. This was soon moved to St Thomas' Peace Garden in Bath Street when Centenary Square was developed.

The foundation stone was laid by the Prince of Wales, later Edward VIII, on 12 June 1923. The official opening by HRH Prince Arthur of Connaught took place on 4 July 1925. The £60,000 to build the memorial was raised through public subscription and built by Birmingham craftsmen. It utilised a new material for Birmingham at the time: Portland Stone. The domed octagonal building has four external bronze statues by local sculptor, Albert Toft. These represent the Army, Navy, Air Force and Women's Services.

Below left: Birmingham Hall of Memory.

Below right: Marble memorial and rolls of honour.

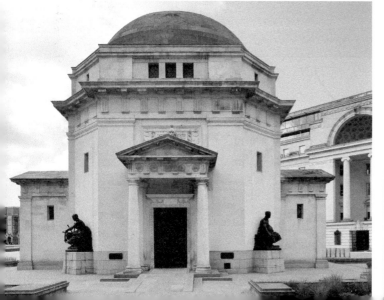

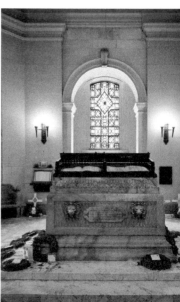

Inside the building a stained-glass window depicting a cross by Richard Stubington overlooks a Siena marble shrine and bronze casket, containing the rolls of honour for both world wars. A third roll of honour contains the names of those fallen in later conflicts. Three reliefs by William Bloye represent the First World War. Call, Front Line and Return portray Birmingham men being called to arms, under fire and returning home wounded.

Hamstead Colliery

Hamstead Colliery on the Black Country border is often described as the only coal mine in Birmingham; however, at least one other mine is recorded at Perry Barr, but became disused in the nineteenth century. The local press reported that 520 acres of the Hamstead Estate had been purchased in 1875 by the Hamstead Colliery Company from General Studd, and by 1880 coal had been discovered. Situated on the edge of the South Staffordshire coal field it was one of the deepest mines in the district. The mine was beset by accidents, falls, explosions and a serious fire in 1898, which threw hundreds of men out of work.

On Wednesday 4 March 1908, a fire broke out underground at the bottom of a pit shaft. It is thought a box of candles ignited. While some escaped, twenty-five miners were cut off by fire and dense smoke. Rescue teams called in from Yorkshire with breathing apparatus made valiant attempts to reach the trapped men but to no avail. On the first day of this rescue attempt John Welsby died when he ran out of air. It took a week to clear the dense smoke and in all twenty-six men had lost their lives. A poignant message was found scrawled underground by six of the miners. It read, 'The Lord preserve us. For we are all trusting in Christ.'

Hamstead Colliery closed in 1965, but in 2008 a monument dedicated to the memory of the men who died in 1908 was erected by the Hamstead Miners Memorial Trust.

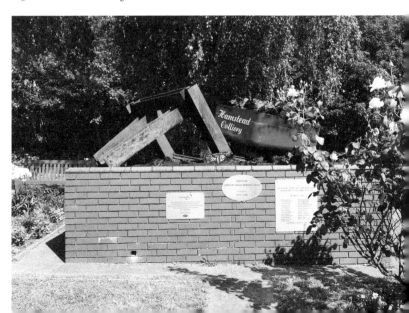

Hamstead Colliery mining disaster memorial.

Ikon Gallery and Brindleyplace

When Oozells Street School opened in 1878 it was surrounded by small-scale industry with a catchment area of mainly back-to-back houses. W. E. Forster's 1870 Education Act encouraged the building of many such schools. The architects were the firm of Chamberlain and Martin who held the contract to build Birmingham Board Schools. John Chamberlain would later design the Birmingham School of Art. At various times it was also a secondary school and college building until finally closing in the late 1960s. In 1981 the building was Grade II listed before the mainly derelict area was regenerated from 1993 by Argent to create Brindleyplace, an innovative mixed-use canalside development. Named after canal pioneer James Brindley, Brindleyplace is home to major tourist attractions such as the National Sea Life Centre together with shops, bars, restaurants, commercial buildings and the Crescent Theatre. World-class venues close by include Arena Birmingham (formally the NIA) and the International Convention Centre (ICC) incorporating Symphony Hall.

By 1994 the Ikon Gallery of contemporary art (Ikon means image) was outgrowing its previous home on John Bright Street. A new venue was required, and the old Oozells Street School proved to be ideal. While retaining the Grade II listed exterior,

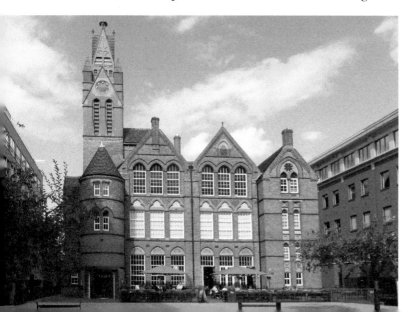

The Ikon Gallery.

the interior was completely redesigned to create the gallery space and the previously demolished Victorian tower replaced. The Ikon gallery aims to display the best in contemporary art and includes a popular café on the ground floor.

Iron: Man

In 1993 the Trustee Savings Bank (TSB) made a gift to the city of Birmingham of a statue created by renowned sculptor Antony Gormley. The iron statue represents the industrial heritage of the region. According to Birmingham Museums Trust it was cast at Firth Rixson, which was formerly known as Bradley and Foster of Darlaston.

The feet of the 20-foot-tall leaning statue are buried in the ground and it weighs in at 6 tons. Once erected in Victoria Square it quickly acquired the nickname 'Iron Man', although it was originally named *Untitled*. Gormley approved of this name change but insisted on adding a colon to become *Iron: Man*. He is perhaps best known for his gigantic *Angel of the North* in Gateshead and his work is often considered controversial. When the late Princess Diana opened the refurbished Victoria Square in May 1993, it was rumoured that the statue had been covered up so she didn't have to see it! When TSB moved their headquarters out of Birmingham some people felt they should take the statue along with them but as a gift to the city of Birmingham it remained and has become a well-known local landmark.

At the time of writing, the statue had been temporarily removed to make way for an extension to the Midland Metro but a painted plaster model or maquette by Antony Gormley is stored at the Birmingham Museum Collection Centre in Nechells and can be viewed on open days.

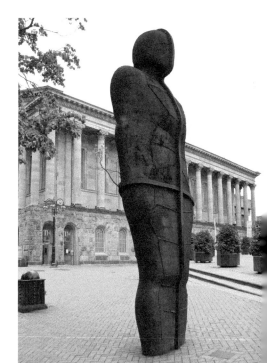

Iron: Man, by Anthony Gormley. (Contributor: Alamy Stock Photos)

Jewellery Quarter and Museum

Birmingham's Jewellery Quarter grew up out of the manufacture of 'toys'. This referred to virtually any small items made of metal. Birmingham was especially known for its high-quality buttons and badges. A logical development was to produce more expensive items in silver or gold. A tremendous boost for the trade came in 1773 when Birmingham was granted its own Assay Office.

By the end of the eighteenth century the Colmore estate had been developed into what is now the Jewellery Quarter. Houses with outbuildings, which could be used as workshops attracted craftsmen, many of whom would go on to build the factories that would eventually employ thousands of skilled men and women. The nineteenth century was a boom time for the Jewellery Quarter, which had built up an enviable reputation

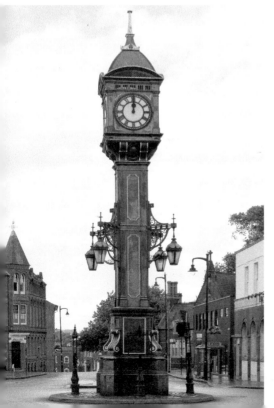

The Chamberlain Clock.

Museum of the
Jewellery Quarter.

for best-quality jewellery carrying Birmingham's own hallmarks. Along with jewellery, the area had its own mint and was also a centre for the manufacture of nibs and pens. The heart of the Jewellery Quarter is marked by a fine clock tower in honour of one-time mayor and MP for Birmingham, Joseph Chamberlain, who once lived there.

The Museum of the Jewellery Quarter is conveniently placed near the Metro station. When the Smith and Pepper jewellery factory closed in 1981, they left everything behind in what is now the museum. The history of the Jewellery Quarter can be explored here together with guided tours and craft demonstrations in the preserved workshop.

Joseph Chamberlain, Mayor of Birmingham

The name Joseph Chamberlain looms large over Birmingham. Born in London, the eighteen-year-old was sent to Birmingham to work for Nettlefold and Chamberlain, the family screw making business. Here he would become a partner and make his fortune. Able to retire in 1874 aged just thirty-eight, he had been elected mayor the previous year. Chamberlain had entered politics in 1869 campaigning for education reform. As mayor, one of Chamberlain's first decisive actions was to municipalise Birmingham's gas supply by buying out the two local companies. By 1876 he had done the same with the Birmingham Waterworks Company. These reforms of utilities through civic control became known as 'gas and water socialism'.

The 1875 Artisans' and Labourers' Dwellings Improvement Act gave Chamberlain a unique opportunity to transform the centre of Birmingham. The Act was principally designed to encourage slum clearance, but Chamberlain went well beyond this to create a grand improvement scheme around the new Corporation Street. This was to be a Parisian-style boulevard with shops, restaurants and entertainment venues together with offices and the Law Courts. Corporation Street was rather sarcastically

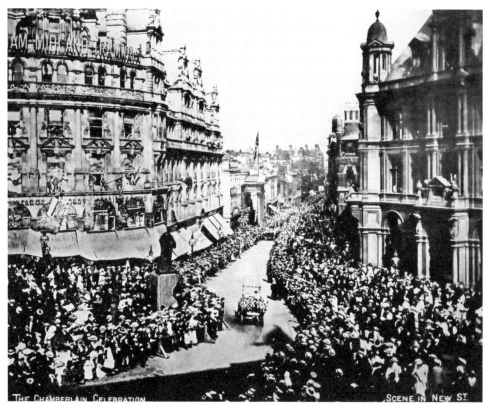

Crowds in New Street celebrating Joseph Chamberlain's seventieth birthday in 1906. (Photo by Birmingham Museums Trust, licensed under CC0)

nicknamed 'La Rue Chamberlain', but nevertheless it transformed what would soon become the city of Birmingham.

In 1876 Joseph Chamberlain was elected Member of Parliament for Birmingham. A statesman of international stature, he was Secretary of State for the Colonies during the Second Boer War. He was instrumental in getting the Elan Valley Water Scheme through Parliament and helped found the University of Birmingham.

Joseph Sturge

The statue of Joseph Sturge standing in front of the Birmingham Marriott Hotel was moved a short distance from the Five Ways island in 1925. Sculpted by John Thomas, the statue was unveiled in 1862 in front of a crowd of 12,000 people.

Joseph Sturge was a Quaker, philanthropist and campaigner against slavery. In 1833 a bill to abolish slavery throughout the British Empire was passed by Parliament. It was not full emancipation as former slaves became unpaid 'apprentices' and given food and lodging for a period of six years. While slave owners were generously

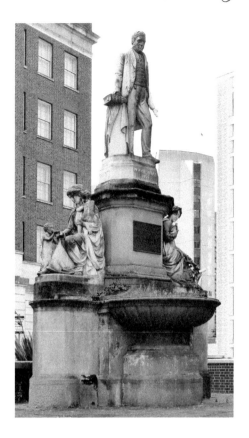

Joseph Sturge Memorial.

compensated, the slaves themselves were not. Sturge travelled to the West Indies in 1836 to observe conditions for himself and on his return led a vigorous campaign to achieve full emancipation. He was successful and the apprenticeship system was ended in 1838.

Over the 1840s and 1850s Joseph Sturge became heavily involved in the peace movement and helped organise international conferences. He was an early pioneer of arbitration and in 1850 went to Schleswig-Holstein and Denmark to try and prevent a war. In 1854 he was sent by the Society of Friends in a deputation to the Russian tzar to try and avert the Crimean War.

His tireless work for the poor in Birmingham including public parks and washhouses, reformatories for delinquents, teetotalism, education and male suffrage all added to the call to erect a statue to the memory of Joseph Sturge 'Apostle of Peace' after his death in 1859.

Josiah Mason

Son of a Kidderminster weaver, Josiah Mason was a self-made man. With little schooling he taught himself to read and write. In 1816 he moved to Birmingham

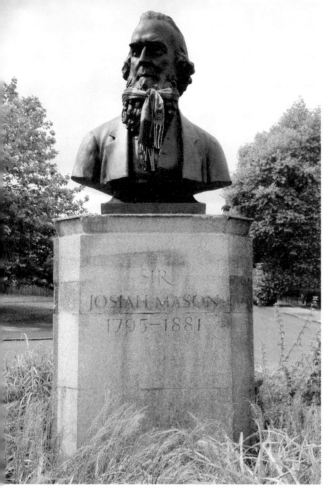

Bronze bust of Josiah Mason in Erdington.

and was employed by his uncle, Richard Griffiths, to run a jewellery and toy-making business ('toys' being buttons, buckles, etc.). By 1824 he had purchased a split ring business from his friend Samuel Harrison. Here he made his fortune after improving and mass producing the split ring to become the modern-day keyring, and then becoming one of the world's largest producers of pen nibs. Together with George R. Elkington he became involved with electro-plating and copper smelting among other lucrative enterprises.

Having amassed his fortune, by 1858 Josiah Mason was turning to philanthropy. He opened almshouses in Erdington, which by 1868 had become an orphanage for 300 children situated on what is now Orphanage Road. This was later enlarged to house 500 orphans. Entry though was strictly limited to legitimate orphans who had lost both parents.

Josiah Mason's great contribution was undoubtedly the foundation of Mason Science College in 1875, which opened to both male and female students in 1880. Mason College was destined to become the foundation of the University of Birmingham.

A bronze bust of Josiah Mason stands at the junction of Orphanage Road and Chester Road in Erdington. It is a bronze cast by William Bloye of an earlier marble statue. The bust is famous locally for being 'dressed up' on special occasions!

K

Kings Norton

From its Anglo-Saxon beginnings, the area is recorded in the Domesday Book and continued to prosper being awarded a market charter by James I in 1616. Unlike Parliamentarian Birmingham, during the English Civil War Kings Norton remained loyal to the king. A group of remarkable medieval buildings on the village green are now known as St Nicolas Place. Adjacent to the originally medieval church is the Tudor Merchant's House and the Old Grammar School. Both of these historic buildings were restored with money from the Heritage Lottery Fund after winning the BBC's *Restoration* programme in 2004.

The Tudor Merchant's House, built circa 1492, was home to wealthy wool merchant, Humphrey Rotsey. Part of the building had been a public house, the Saracen's Head, until it was presented to the parish by the M&B brewery in 1930. In 1643 during the English Civil War Queen Henrietta Maria, on her way to join Charles I at Oxford, is said to have stayed overnight here in some comfort while her Royalist army of around 5,000 men camped where Kings Norton Park and 'Camp Lane' is now.

The timber-framed Old Grammar School in the churchyard dates back to the fifteenth century. During the English Civil War, the opinionated curate and headmaster Thomas Hall held Parliamentarian sympathies despite residing in mainly Royalist Kings Norton. He had an extensive library of books which is now held

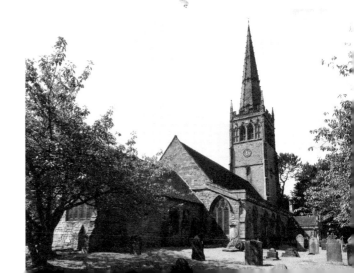

St Nicolas Church.

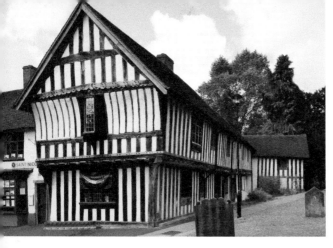

Tudor Merchant's House.

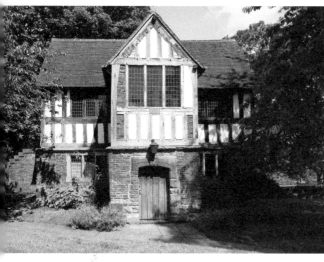

The Old Grammar School.

by Birmingham Library. The Old Grammar School was nearly lost in 1909 when two militant Suffragettes broke in with the intention of burning it down. Fortunately, they were so taken with the building that they reportedly left a message on the chalkboard which read, 'Two Suffragists have entered here, but charmed with the old-world room, have refrained from their design of destruction'.

First recorded in the thirteenth century, St Nicolas Church has an impressive fifteenth-century crocketed spire and magnificent nineteenth-century stained-glass windows by Kempe and Harman. In 1940, pacifist Wilbert Vere Awdry became curate of St Nicolas Church. His son Christopher became ill with measles two years later and Awdry would make up stories about three railway engines – Edward, Henry and Gordon – from the fantasy land of Sodor. It was his wife Margaret who persuaded Awdry to get them published. His first book, *The Three Railway Engines*, appeared later in 1945. In 1946 a second book was published that featured a little tank engine made in wood for Christopher one Christmas. From such simple beginnings, Thomas the Tank Engine by Reverend W. Awdry was born.

Following the extensive restoration, St Nicolas Place is now a tourist attraction and events venue with guided tours, educational visits and its own café.

L

Longbridge and Austin

Longbridge and Austin are names synonymous with Birmingham's motor manufacturing industry. Another was Wolseley, although they were primarily manufacturers of sheep shearing equipment. Their very first tiller driven car was designed in 1895 by none other than Herbert Austin. Austin went on to manage the car building side of the company until 1905 when he resigned to start the Austin Motor Company. Austin purchased the old White and Pike printing works in Longbridge together with 8 acres of land. The company was an immediate success.

By 1914 Austin was employing two thousand workers. Massive expansion followed during the First World War, with Austin producing military vehicles, shells, guns and

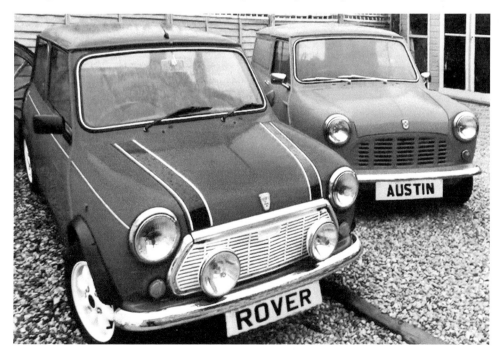

Iconic classic minis. (Courtesy of Steve Amos and James Perrins)

aeroplanes requiring the creation of an airfield at nearby Cofton Hackett. This would be repeated during the Second World War when everything from small components to Lancaster Bombers would be produced.

Austin went from strength to strength and in 1952 merged with Nuffield to form the British Motor Corporation (BMC). This merger included arch-rivals Morris, MG, Riley and ironically Wolseley where the now deceased Herbert Austin had started. The company suffered mixed fortunes after becoming part of British Leyland in 1968. Later it became a subsidiary of British Aerospace and then BMW who sold the company to MG Rover, which went into liquidation in 2005.

It was under BMC in 1959 that Sir Alec Issigonis designed one of Britain's most iconic cars, the Austin Mini, which continued in various guises right up until 2000.

Lunar Society and Soho House

Soho House was the home of industrialist Matthew Boulton from 1766 until his death in 1809. He acquired the lease to the Soho estate in 1761 but initially it was home to

Soho House.

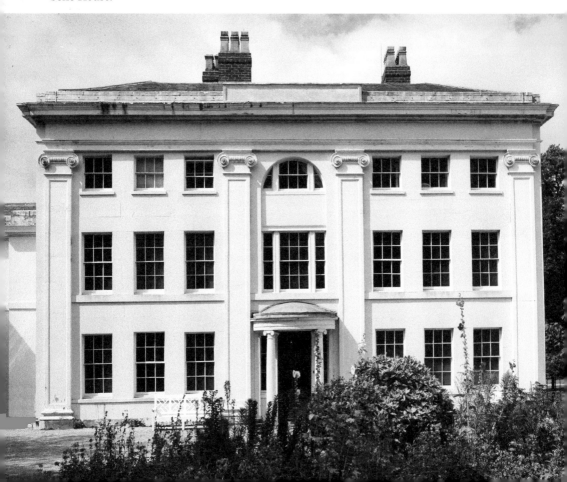

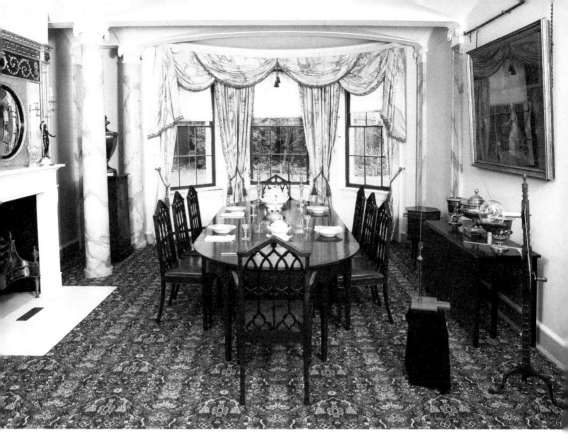

The Dining Room or 'Lunar Room' at Soho House where the Lunar Society met. (Photo by Birmingham Museums Trust, licensed under CC0)

Boulton's partner, John Fothergill. In 1766 Boulton moved into Soho House to be close to his Soho Manufactory. By this time the elegant Georgian house and grounds was being extensively improved including the dining room, which would become known as the Lunar Room.

Soho House was a favourite meeting place of the Lunar Society, initially known as the Lunar Circle, who met in members' homes from 1765. They referred to themselves as lunatics (or 'lunaticks') as they met on the nearest Monday to the full moon to light their way home. Some of the finest minds of their age such as Erasmus Darwin, Matthew Boulton, James Watt, Josiah Wedgwood, Joseph Priestley, James Keir and other distinguished men would meet for a splendid dinner and to explore the latest advances in natural philosophy (science), medicine and industry through discussion and experimentation. Members also included educational and anti-slavery reformers such as Thomas Day. Lunar Society members would literally revolutionise the Industrial Revolution.

After having had such a profound influence on the Midlands Enlightenment and the Industrial Revolution the Lunar Society was finally dissolved in 1813 by the last four surviving members. Soho House is now a museum having been restored back to the time when Matthew Boulton entertained distinguished members of the Lunar Society.

Magnetron

In February 1940 a laboratory experiment at the University of Birmingham was to change the course of the Second World War. Professor Marcus (Mark) Oliphant had received funding from the Admiralty to perfect a microwave device small enough to be incorporated in radar equipment for aircraft such as night fighters and for anti-submarine warfare. This was the brief given to physicists John Randall and Harry Boot. Their radically improved cavity magnetron design produced unprecedented pulsed microwave power outputs at the required 10 cm wavelength. The impact of their achievement in the war against enemy bombers and U-boats particularly cannot be underestimated.

Under great secrecy the General Electric Company Research Laboratories at Wembley perfected Randall and Brown's laboratory model to produce a robust version that could be incorporated into compact radar units. This was just in time for the new cavity magnetron to be included in Henry Tizard's Mission to America in 1940. Winston Churchill had sanctioned the remarkable decision to share Britain's top secrets with the Americans hoping to take advantage of their considerable production capacity and for financial and technological assistance. Official scientific research historian James Phinney Baxter III would call the secrets contained in

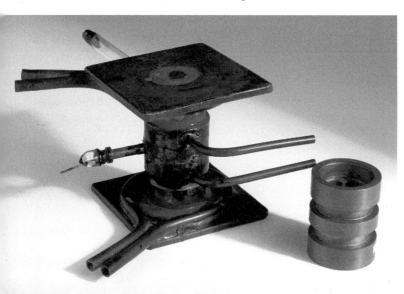

Original cavity magnetron, 1940. (Science Museum/ Science and Society Picture Library)

Tizard's metal box, including the cavity magnetron, 'the most valuable cargo ever brought to our shores'. Thanks to John Randall and Harry Boot effective airborne radar was now a reality. As well as helping to win the Second World War for the Allies, magnetrons are also found in today's microwave ovens.

Memorial to the Birmingham Blitz

According to the Imperial War Museum Birmingham was the third most bombed city during Second World War after London and Liverpool, but the full extent of the Blitz in Birmingham was not reported at the time. The area was vital to the war effort supplying vehicles, weapons and aeroplanes. War production was carried out all over Birmingham, with notable examples being the Spitfire factory at Castle Bromwich and Birmingham Small Arms (BSA) at Small Heath. The lives of 53 BSA workers were tragically lost during a single air raid in November 1940. Fears of revealing valuable strategic information to the enemy meant that the devastation and death toll endured during the Blitz was largely suppressed. Birmingham was often simply referred to as a 'town in the Midlands'.

The raids started on 8 August 1940 and continued until 23 April 1943. Over 9,000 people were injured including the 2,241 who died. Due mainly to campaigning by the Birmingham Air Raids Remembrance Association (BARRA), a memorial honouring the victims was unveiled in Edgbaston Street near St Martin's Church in October 2005.

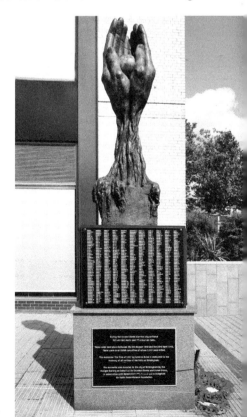

Birmingham Blitz *Tree of Life m*emorial.

Halcyon Gallery donated *The Tree of Life* to the city of Birmingham in conjunction with Birmingham City Council and BARRA. The bronze sculpture by Lorenzo Quinn features two hands holding a sphere representing the search for a better future. The names of the 2,241 people killed in Birmingham in the Blitz are commemorated on the plinth.

Metchley Roman Fort

Traces of early human occupation of Birmingham are found at places such as Kingstanding where a 20 metre Neolithic or early Bronze Age burial mound is still in evidence. In Sutton Coldfield, part of Birmingham since 1974, thousands of years of occupation include six Bronze Age burnt mounds excavated in 1926 and a well-preserved section of Roman road in Sutton Park. This is Icknield Street (also Ryknild or Rycknield), although these names are medieval not Roman. The road connected the Roman fort at Wall near Lichfield to Birmingham's only known Roman fort – Metchley – and carried on south to Alcester. Another major connection from Metchley went south-west to Droitwich.

Metchley Roman Fort lay between what is now the University of Birmingham and the Queen Elizabeth Hospital in Edgbaston. As with Icknield Street the original Roman name is lost to history. There were two forts at Metchley with the first being constructed around AD 48. It was occupied by Roman soldiers for about ten years but then became a supply depot. During the uprising of the Iceni tribe around AD 60 under Queen Boudicca (Boadicea), a second smaller fort was established in case of civil unrest. Some twenty years later the army had moved on and Metchley fell to civilian use until around AD 200. Nothing remains above ground of the original earth and timber structure. Close to University station, information panels describe what Metchley Fort would have been like during the Roman occupation of nearly 2000 years ago.

Reconstructed Roman earthworks in the grounds of the Queen Elizabeth Hospital.

N

Nelson's First Statue

Statues to Vice Admiral Horatio Lord Nelson are nothing unusual, except the one in Birmingham's Bullring has the distinction of being a first for Britain. Lord Nelson's remarkable naval career had started when he was aged just twelve. By the age of twenty he had been made captain. During the French Revolutionary Wars, which Britain entered in 1793, Nelson helped capture Corsica but lost the sight in one eye at the battle of Calvi. Later he was to lose his right arm at the Battle of Santa Cruz de Tenerife. Known for occasional disregard of direct orders, at the Battle of Copenhagen Nelson placed a telescope to his blind eye and claimed he could see no signal to withdraw.

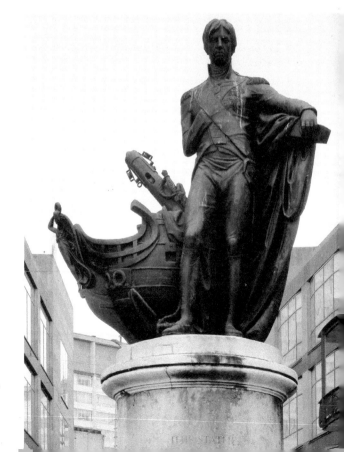

Lord Nelson's statue in the Bullring.

One of Nelson's famous victories was the Battle of the Nile where he destroyed Napoleon's fleet. Although married, while in Naples he fell in love with Lady Emma Hamilton who was also married. This did not stop them having a child together, Horatia, in 1801. That same year Nelson had been promoted to Vice Admiral. In 1805 he won his famous victory against the French at the Battle of Trafalgar. Nelson was mortally wounded during the battle and his body was given a state funeral back in Britain.

Nelson enjoyed a triumphant visit to Birmingham in 1802 and it was mainly contributions from the grateful people that paid for the monument by Sir Richard Westmacott. Unveiled in 1809, this was Britain's first publicly subscribed memorial statue of Lord Nelson.

New Street Station

New Street is classed as an underground station but when it was officially opened in 1854 this was far from the case. It opened to passengers in 1851 to effectively replace three existing stations around Curzon Street. New Street was originally known as the new 'Grand Central' station of Birmingham. It came about through a merger of the London & Birmingham and Grand Junction railways to form the London & North Western Railway. The official opening in 1854 included the Queens Hotel on

New Street station in the early 1900s. (Contributor: Alamy Stock Photos)

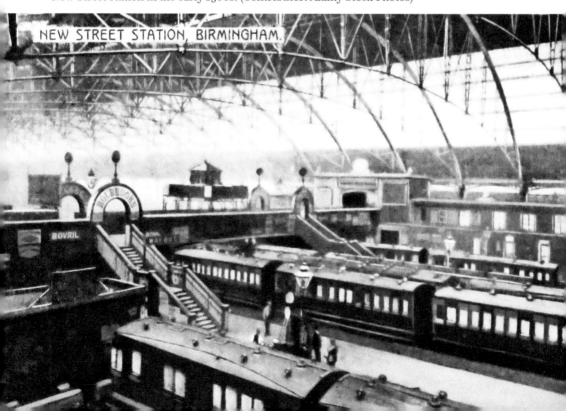

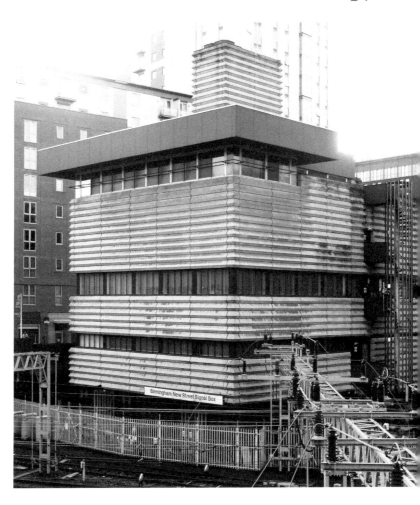

New Street station's brutalist signal box.

Stephenson Street, which formed the main entrance to the station through a series of arches.

When New Street first opened it was a magnificent station. Designed by E. A. Cowper, it featured the largest single span, iron and glass arched roof in the country at 212 feet wide. It was built by Fox, Henderson & Company who also fabricated the Crystal Palace for the Great Exhibition of 1851. Severe bomb damage during the Second World War meant that the original roof had to be replaced. The Victorian station was demolished in 1964 to be replaced by a much-derided design involving burying the platforms beneath a massive concrete deck to support a shopping centre. The new station opened in 1967.

One redeeming feature was the strikingly brutalist signal box built in 1964. Squeezed into an almost impossible space, the Grade II listed building is of national importance and described by Historic England as being very much a 'one off'. Following further massive redevelopment New Street Station now forms part of the new 'Grand Central' shopping centre.

Old Crown

The Old Crown public house at Deritend is the only surviving in-situ secular medieval building in central Birmingham. Traditionally, it is reputed to date back to 1368, although the present building is almost certainly fifteenth century with later additions. It was the Guildhall and school for the Guild of St John the Baptist of Deritend. The Guildhall was a place for members to meet and pray, as well providing a school for the member's children.

Exactly when the building became a public house is not known. It is mentioned in a marriage settlement of 1666, which refers to an inn 'called by the sign of the Crowne situated in Birmingham in a street called Deritend'. An earlier sale document of 1589 also refers to the 'deedes of the Crowne house' and so it may well have been an inn at that time. Elizabeth I is reputed to have stayed here for one night in 1575 following an extended visit with Robert Dudley at Kenilworth Castle. If so, it is possible that

The Old Crown, Deritend.

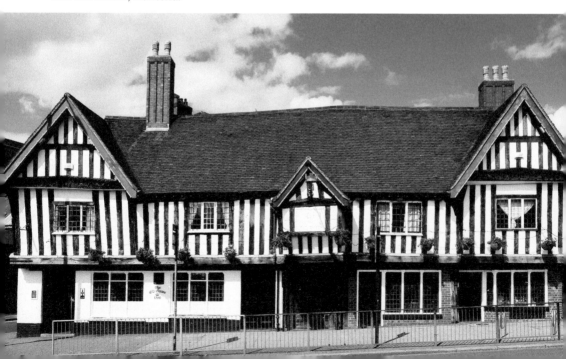

the naming of the Crown may refer to that event, especially as Birmingham was Parliamentarian during the English Civil War.

In 1643 the building was fortunate to avoid being destroyed by Prince Rupert's Royalist soldiers during the Battle of Camp Hill. In the mid-nineteenth century Birmingham Council had plans to demolish it as part of an 'improvement' scheme. It was only through the efforts of local antiquary Joshua Toulmin Smith that the Old Crown was saved and continues to welcome customers.

Old Mint, Icknield Street

The Old Mint on Icknield Street was formerly known as the Birmingham Mint Limited, and, up to 1889, Heaton and Sons. The Mint owed its existence to Matthew Boulton, who from 1788 pioneered the mass production of coinage. Following the death of James Watt Jr in 1848, it was decided to close the Soho Manufactory and associated Mint. In 1794 Ralph Heaton had founded a Slaney Street button making business. In 1850 Ralph Heaton II purchased Boulton's coin presses at auction for use at his Bath Street die-sinking workshop.

The new mint was a tremendous success. So much so that by 1860 the site on Icknield Street had been purchased to house new lever presses and a workforce of 300. In 1862 they moved into the Italianate-style red-brick factory, now under Ralph Heaton III. It was the largest private mint in the world.

In the 1920s, and not for the first or last time, the state-owned Royal Mint posed a threat when it diversified beyond the British Empire, taking much of Birmingham's business. In the 1960s a consortium agreement was made with the Royal Mint to fairly apportion overseas orders. Birmingham Mint's peak came in 2000 when millions of pounds worth of orders for Euro coins were placed, but by 2003 it was all over. A contractual disagreement with the Royal Mint led to Birmingham Mint being put into administration. Despite determined efforts to save it, Birmingham had lost its historic mint.

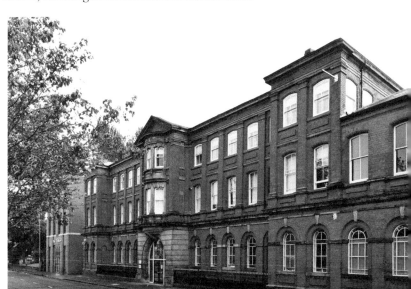

Former Birmingham Mint, Icknield Street.

Peaky Blinders

The *Peaky Blinders* television series created by Steven Knight is an intriguing mix of fact and fiction. First references to 'Peaky Blinders' appear in the newspapers as early as 1890 in conjunction with teenage 'Slogging Gangs'. The name may refer to the wearing of peaked caps or it may derive from the wearing of billycock (bowler) hats with the brims moulded to a point and worn over one eye. A graphic report of the beating up of a young man called George Eastwood from Small Heath appeared in the *Birmingham Mail* on 24 March 1890. It is very detailed, but there is no mention of the 'Peaky Blinder' gang involved having blades sewn into their caps. Indeed, King Camp Gillette didn't come up with idea of a double-edged disposable razor blade until

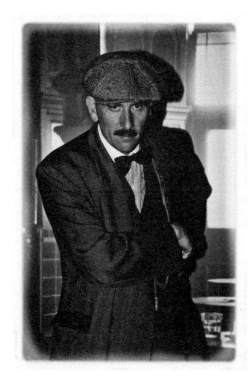

By order of the Peaky Blinders. (Copyright Black Country Peakys, Darren 'Slim' Butler and Stuart Lambeth)

1895, and mass production didn't commence until 1903. The television series is set after the First World War, but by then the real Peaky Blinders had all but disappeared.

Another element comes into the story and that is illegal gambling. The 1845 Gaming Act and the 1853 Betting Act effectively outlawed gambling apart from on-track betting on horse races and later greyhound racing. The effect of this was similar to the prohibition of alcohol in America in that it forced everyday bookmaking underground and into the hands of often violent gangs. It was 1961 before the opening of legal betting shops in Britain. Here then are the two main elements, skilfully blended to create the hugely popular Peaky Blinders.

Post Office Tower

Now known as the 'BT Tower', it is by far the tallest structure in Birmingham, standing at 152 metres and visible for many miles. It was built by the Ministry of Public Building and Works under senior architect M. H. Bristow. Construction started in 1963 and completed in 1965, although it was not officially opened by the Lord Mayor of Birmingham, Alderman James Meadows, until October 1967. Given its height and the fact that it needed to be a stable platform for transmitting equipment the design incorporated articulated corners to resist the effects of the wind.

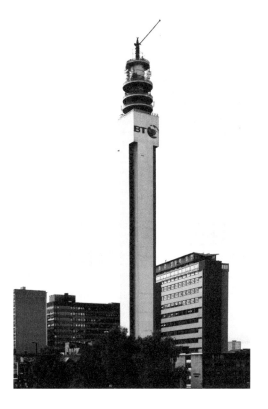

The former Post Office Tower.

Originally built as a communication tower its height was necessary to clear any tall buildings and provide line of sight connection to similar towers such as London. The height was limited to 152 metres because of the need to provide for non-standard approaches to Birmingham Airport. Development of the digital fibre network meant that the last of the large analogue dishes were removed in 2012 to be replaced by some eighty smaller microwave dishes. It was designed with five circular galleries at the top and twenty-six storeys including technical areas, workshops, offices and even a staff canteen.

Despite being somewhat utilitarian the tower was much improved by a new contrasting colour scheme in 2003. For some years the twenty-second floor has played host to some rather special guests. BT engineers installed a pebbled tray, which proved ideal for a pair of peregrine falcons to build their nest.

Priestley Riots

The Priestley Riots were also known as the 'Church and King Riots'. The summer of 1791 was far from Birmingham's finest hour. Joseph Priestley was a gifted scientist

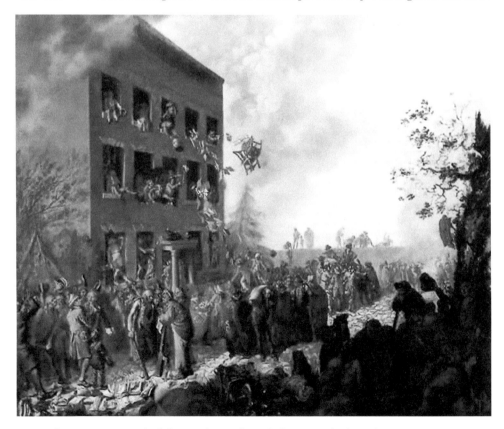

Rioters burning Dr Priestley's house. (Contributor: Alamy Stock Photos)

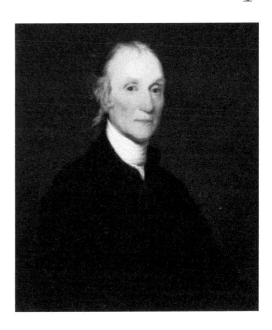

Portrait of Dr Joseph Priestley. (Photo by
Birmingham Museums Trust, licensed
under CC0)

and leading member of the Lunar Society who is credited with the discovery of oxygen.
He was also a dissenter from the Church of England and showed open support for
the French Revolution. There were fears that such dissenters might fan the flames
of revolution against the established Church and the monarchy. In Birmingham,
it all came to a head on 14 July 1791 – on the second anniversary of the storming
of the Bastille. A dinner had been booked at Thomas Dadley's Hotel in Temple Row
to celebrate the event although Priestley himself was not there. What followed was
fuelled by propaganda, rumour and false information.

An angry mob in support of church and king formed but could still have been
halted by the magistrates if they had called for the militia in time, but they did not.
The mob first attacked Priestley's own Unitarian New Meeting House followed by
the Old Meeting House. They then turned their attention to destroying Fair Hill,
Priestley's house and laboratory. The next three days saw a total of four dissenting
churches and twenty-seven houses destroyed before the military ended the rioting on
17 July. The Priestley family had fled before their house was burned, never to return.
Birmingham and the Lunar Society had lost one of its greatest scientists.

Prince Rupert and the Battle of Birmingham

At the start of the first English Civil War in 1642 Birmingham had declared
for Parliament but had no defensible castle or significant resident garrison.
The Parliamentarian sympathisers of Birmingham seem to have invited inevitable

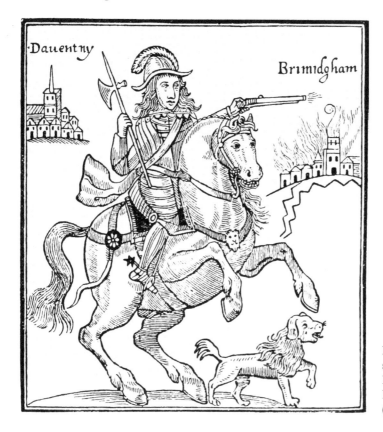

Pamphlet cover
showing Prince
Rupert burning
Birmingham.
(The British Library)

retribution in the autumn of 1642 by attacking a Royalist baggage train on its way to Edgehill. The baggage train was looted, and prisoners delivered to the Parliamentarian garrisons at Warwick and Coventry. The well-known phrase to be 'sent to Coventry' may well refer to Parliamentarians ostracising and refusing to even speak to captured Royalist prisoners.

Terrible retribution came in the form of Prince Rupert's march to successfully take Lichfield for the Royalists. On Easter Monday 1643 he camped at Kempe Hill, later renamed Camp Hill, to find earthworks and barricades protecting Birmingham together with local inhabitants and musketeers from the garrison at Lichfield. In the ensuing battle of Camp Hill as the action is also known, the Royalists eventually bypassed the defences albeit with the loss of Lord Denbigh, who died some days later of wounds inflicted during the battle. Having gained access to Birmingham, Royalist soldiers set about killing, pillaging and burning buildings. Parliamentarian pamphlets at the time described in somewhat lurid detail alleged atrocities by Prince Rupert's soldiers, particularly against women. Pamphleteers and commentators also derided Rupert's use of arson as a military tactic and in particular, the 'miserable destruction of Burningham (Birmingham) by fire' and by describing his atrocities as the 'Birmingham Butcheries'. A public outcry even led to Charles I himself petitioning his nephew Prince Rupert to 'behave more gently'.

Q

Queen Victoria Statue

Up until 1901 Victoria Square was known as Council House Square. On 10 January 1901 a newly commissioned statue of Queen Victoria in marble by Thomas Brock was unveiled and the square renamed in the queen's honour. Unfortunately, Queen Victoria was never to see the new statue as she died just twelve days later on 22 January. Brock's original statue was not strictly speaking original as patron Mr (later Sir) William 'Henry' Barber, a notable Birmingham solicitor and property developer, insisted on a copy of Brock's earlier statue for Shire Hall in Worcester. It was Sir Henry's widow who would later fund the Barber Institute of Fine Arts opened in 1939 at the University of Birmingham in his memory.

When the Festival of Britain took place in 1951 the statue was recast in bronze and given a new marble pedestal both by William Bloye, as by this time the original had suffered irreparable damage. The new bronze statue was unveiled by the Queen, then Princess Elizabeth.

Queen Victoria is not alone as a small commemorative plaque is embedded nearby which reads, 'On Site Ebony 1992-93' with a paw print in the middle. Ebony was a black labrador who used to accompany her owner, one of the workmen pedestrianising the square. She would wear her own high visibility jacket and carry tools when she wasn't begging chocolate from passers-by. Hopefully Queen Victoria was amused!

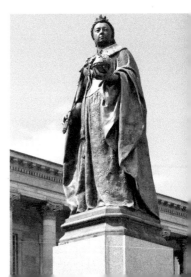

Statue of Queen Victoria.

Rotunda

Birmingham has had something of a love-hate relationship with the Rotunda building. Generally disliked when it was completed in 1965, when plans were put forward to demolish it there was a public outcry in favour of saving it. When constructed the now iconic cylindrical building was not quite as architect James A. Roberts intended. The original design of office block and a bank also included a cinema and rotating rooftop restaurant, neither of which were built due to financial restraints at the time. Originally intended to be twelve storeys, it actually ended up being twenty-five with two levels underground.

The architect had intended the Rotunda to look like a giant candle topped by a colour changing weather beacon! After surviving various plans to demolish it along with development of the ageing 1960s Bullring, the building was finally saved by obtaining

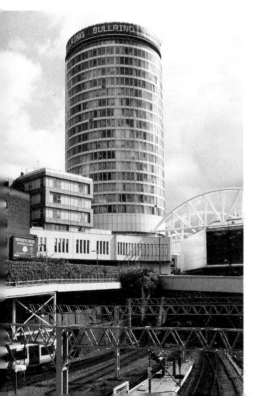

The Rotunda.

Grade II listed status in 2000. By 2008 the Rotunda had been completely refurbished by Urban Splash to a design by Birmingham-based Glenn Howells Architects. During the conversion to high-rise apartments and a boutique hotel, the half-size windows, which had been installed to save money, were replaced with the floor to ceiling windows as specified in Robert's original design, giving the building a fresh new look. A small poem engraved in the wall of the Bullring celebrates the Rotunda's against all odds survival:

> Rotunda,
> Some wanted you round,
> Some wanted you square,
> Still there

Roundhouse

The Roundhouse, built in 1874 at the junction of Sheepcote Street and St Vincent Street, was designed by celebrated local architect W. H. Ward, who had won a design competition organised by Birmingham Corporation. Ward also designed the Great Western Arcade in Colmore Row. Appropriately enough the red-brick building was constructed in a large horseshoe shape as it was used as stables, stores and a canal wharf. The design of the building allowed for horse-drawn carts to access the lower-level canalside via a sloping cobbled ramp. It was ideally placed between the Birmingham Main Line Canal and a goods yard belonging to the London and North Western Region Railway (LNWR).

The building stabled some forty horses of the Public Works Department and served as a base for the city's lamplighters among other things. Goods such as stone for road building would be delivered by canal and the wharf would likely have been used to transport night soil away from the city – a pleasant job for the bargees! Given its

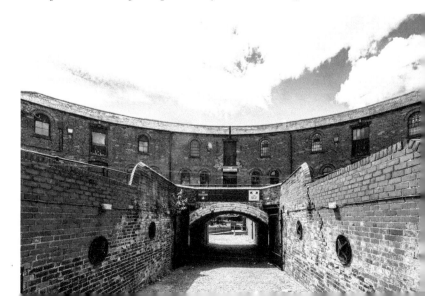

The Roundhouse.
(Contributor: Alamy
Stock Photos)

additional use as a wharf, overnight stabling for canal horses would probably have been offered as the barges passed through.

After falling into disuse, the landmark Grade II listed building is being restored at the time of writing in a joint project between the National Trust and the Canal and River Trust to create a new leisure and enterprise hub.

Rowland Emett

The name might not be well known, but some of his fantastical machines certainly are, particularly to anyone familiar with the film *Chitty Chitty Bang Bang*. Frederick Rowland Emett was born in 1906 and his family moved to Small Heath from London before the First World War. The young Rowland Emett as he was known attended Waverley Grammar School and the Central School of Arts and Crafts also known as the Birmingham School of Art.

Working in advertising before the Second World War, Emett started to sell cartoons to *Punch* and would go on to become one of the magazine's most popular contributors. During the Second World War while working as a draughtsman for the Air Ministry he married Elsie May (Mary) Evans, the daughter of a Birmingham silversmith and very much the business brains of the partnership.

Emett had a great interest in railways and in 1951 created the whimsical Far Tottering and Oystercreek Railway in Battersea for the Festival of Britain, enjoyed by over 2 million visitors. From then on Rowland Emett would be well known for his 'things' as he called his amazing machines. Among many such incredible creations, in 1960 Emett was commissioned to design the mechanical 'Forget-Me-Not' computer for Honeywell. It was then in 1968 that Emett created a series of marvellous machines for the big screen including the 'phantasmagorical' flying car, Chitty Chitty Bang Bang. In 2012, the Rowland Emett Society was formed to celebrate his life, art and truly magical machines.

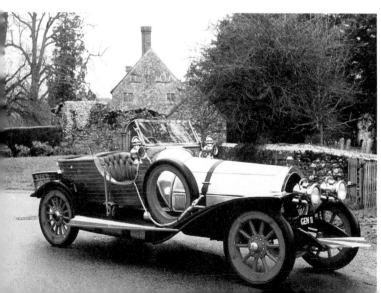

Chitty Chitty Bang Bang 1968 film car. (Copyright National Motor Museum, Beaulieu)

S

St Mary's Church, Handsworth

St Mary's Church lies on the edge of Handsworth Park and is also known as Handsworth Old Church. The red sandstone church was largely rebuilt in the nineteenth century, but there is still some evidence of the small stone Norman church dating back to the twelfth century.

Buried and commemorated here are three giants of the Industrial Revolution: Matthew Boulton, James Watt and William Murdoch. For this reason, the church has become known as the 'Cathedral of the Industrial Revolution' and also the 'Westminster Abbey of the Industrial Revolution'. Within the church there is a marble bust of Matthew Boulton by sculptor John Flaxman together with a stone bust of William Murdoch and a marble statue of James Watt by sculptor Francis Legatt Chantrey.

An intriguing memorial in the churchyard commemorates the gypsies of Black Patch in Smethwick. Now called Black Patch Park, this was originally an area covered in waste from furnaces including those of Boulton and Watt's Soho Foundry. Between 1889 and 1915 a total of thirty-five gypsies from Black Patch were buried here. Two of these were the undisputed king and queen of the gypsies at that time. Esau Smith died in 1901 aged ninety-two and his wife, Sentinia (Henty) Smith, died in 1907 aged ninety-eight. She was buried next to her husband in St Mary's Churchyard.

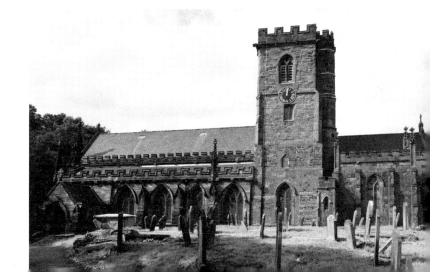

St Mary's Church,
Handsworth.

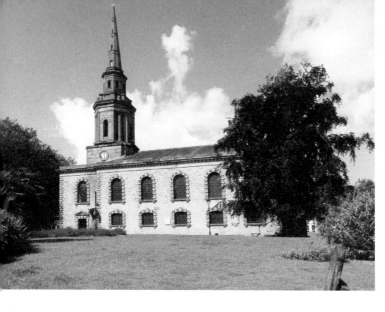

St Paul's Church,
Jewellery Quarter.

St Paul's Church, Jewellery Quarter

St Paul's Church is situated in Birmingham's only remaining Georgian Square. Built on the Coleman family's Newhall Estate between 1777 and 1779, St Paul's Square consisted of fashionable houses with St Paul's Church as the centrepiece. During the nineteenth century expansion of the Jewellery Quarter saw buildings on the square being turned over to factories and workshops. The once fashionable square became less desirable and those who could afford to simply moved away. Many of the buildings have been restored and are Grade II listed, while St Paul's is Grade I listed. Initially a chapel, the church was designed by Wolverhampton architect Roger Eykyn and consecrated in 1779. In 1823, a spire and extension to the tower was added by Francis Goodwin.

Inside the church is the magnificent east window. This is a copy of a painting by Benjamin West of the conversion of Paul executed on glass by Francis Eginton, a former employee of Matthew Boulton. Originally, pews would be rented often to those who had subscribed towards the building costs. Reputedly, both James Watt and Matthew Boulton rented pews here. James Watt may have attended the church on occasions as between 1777 and 1790 he was living at nearby Harper's Hill before moving to Handsworth. Matthew Boulton though was already living at Soho House in the parish of Handsworth before St Paul's Church was built. Indeed, both Matthew Boulton and James Watt are buried in St Mary's Parish Church in Handsworth.

Sarehole Mill

Sarehole Mill is one of only two surviving water mills in Birmingham. The other is New Hall Mill in the Royal Town of Sutton Coldfield, although only subsumed into Birmingham in 1974. At one time there were some 60 mills on the Cole and Rea rivers.

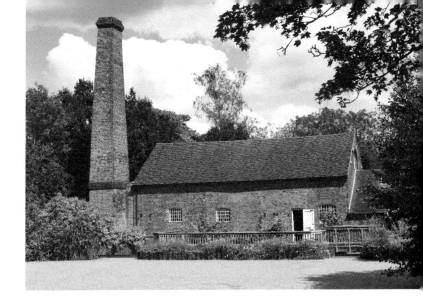

Sarehole Mill Museum.

A mill on the site is recorded in 1542 but the present buildings date mainly to the eighteenth and nineteenth centuries. As well as grinding corn such mills would have been used for sharpening agricultural tools and early metal working activities. Matthew Boulton leased Sarehole Mill from 1756 to use it as a 'flatting mill' for rolling out the sheet steel used in button manufacture before transferring to his new Soho Manufactory. In the 1850s, the mill was again mainly grinding corn but with the addition of a steam engine for extra power. The mill was still providing corn during the First World War but finally closed in 1919. Sarehole Mill has been returned to working order and is now one of Birmingham's popular museums.

As a child author J. R. R. Tolkien and his family lived nearby at No. 264 Wake Green Road, or No. 5 Gracewell as it used to be known. Tolkien and his brother Hilary would play around Sarehole Mill, often being chased away by the miller's flour covered son who they nicknamed, 'The White Ogre'. Then a mainly rural area, it is said to have provided inspiration for Hobbiton in the rural Shire, home to Hobbit Bilbo Baggins.

Selly Manor

Despite the name Selly Manor was never home to the Lords of Selly Oak, although it was a prosperous residence. A late fifteenth-century yeoman's house, it was known as 'Smythes Tenement'. During the sixteenth century it was home to the Setterford family. John Setterford was a well to do attorney and bailiff. Later in the eighteenth century it was known as Selly Hill Farm and the house began to fall into a gradual decline. It was first divided up into two and then three separate dwellings by the nineteenth century and became known as The Rookery. Ironically, the now overcrowded building had become a tenement as originally named.

The delipidated building was saved from inevitable demolition when it was purchased by chocolate maker George Cadbury in 1907. His vision was that it should become a museum in his village of Bournville. In an early example of conservation,

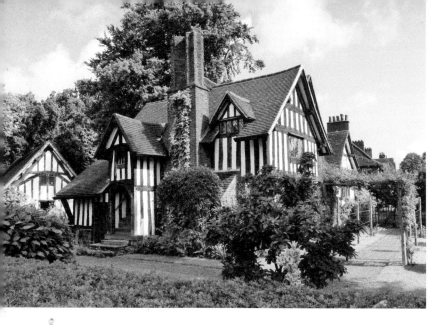

Selly Manor Museum.

the building was relocated and restored between 1912 and 1916 under the supervision of Bournville's principal architect, William Alexander Harvey.

Selly Manor is complimented by Minworth Greaves, a cruck-framed hall from Sutton Coldfield, rebuilt on the same site in 1932 by George Cadbury's son, Lawrence. Likely dating back to the 1300s, this is another secular building that can legitimately lay a claim to be the oldest in Birmingham. Lawrence Cadbury was an avid collector of furniture and domestic objects. The Lawrence Cadbury Collection as it is known is yet another fascinating feature of Selly Manor Museum.

Smethwick Engine

The Smethwick Engine is the oldest working steam engine in the world. Built by Boulton and Watt, the engine was installed in 1779 on Brindley's Birmingham Old Main Line Canal at Smethwick. It was one of two steam engines built on either side of the Smethwick Summit and used to pump water back up in order to operate the locks. The terrain had proved unsuitable for Brindley to dig a tunnel and there was no other way to replenish water lost through the locks locally.

Designed by James Watt, the Smethwick Engine incorporated his great innovation over the earlier Newcomen Engine of a separate steam condenser. This improved the efficiency of the engine making it more powerful but also using far less coal. Watt also used the expansive force of low-pressure steam on top of the piston together with the vacuum created by the condenser beneath the piston to maximise efficiency and power. The engine was in use until 1891 until replaced and put in storage. Later acquired by Birmingham City Council and displayed at the Science Museum in Newhall Street, it now takes pride of place in the Thinktank Museum at Millennium Point where it is still regularly steamed. James Watt is even credited in the Guinness World Records for the oldest steam engine still in working order.

Boulton and Watt's 'Smethwick' steam engine. (Photo by Birmingham Museums Trust, licensed under CC0)

Snow Hill Station

Snow Hill station opened in 1852 with a temporary set of wooden buildings. It was built by the Great Western Railway (GWR) after plans to route the new line from Oxford through Curzon Street station were thwarted by the London and North Western Railway. Originally, Snow Hill was dual gauge, incorporating Brunel's 7 ft ¼ in broad gauge and Stephenson's 4 ft 8 ½ in narrow (now standard) gauge. The station was variously known as 'Birmingham', 'Great Charles Street' and 'Livery Street' until the GWR chose Snow Hill in 1858.

By 1871 Snow Hill had been rebuilt and included J. A. Chatwin's Great Western Hotel in front of the station. The Great Western Arcade was also built in the 1870s after the old broad-gauge cutting was covered over to extend the existing tunnel between Snow Hill and the later Moor Street station.

The Snow Hill station still fondly remembered by many was built between 1906 and 1912. The Great Western Hotel was turned into railway offices and new entrance to the station. With a glass and steel canopy protecting the platforms and curved glass roof over the booking hall, Snow Hill could now compete architecturally with New Street. By 1967 all but local services were routed through New Street. Despite efforts to save it, the station had been demolished by 1977 only to be reopened again in 1987. This time on a much smaller scale, and a shadow of the magnificent Edwardian station it once was.

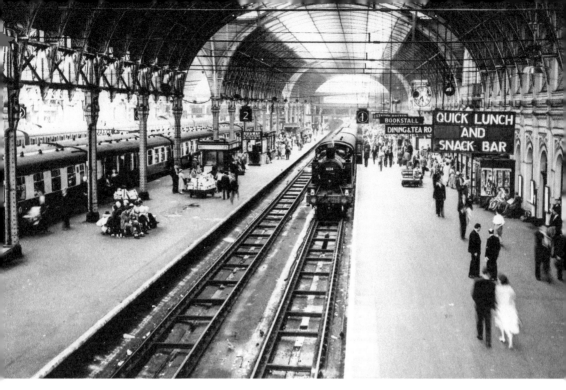

Above: Snow Hill station in the 1950s. (Contributor: Alamy Stock Photos)

Left: Former GWR entrance into the old Snow Hill station on Livery Street.

Soho Manufactory

Not to be confused with the Soho Foundry which came later, the Soho Manufactory was Matthew Boulton's factory in Handsworth. Together with his earlier partner John Fothergill, they obtained a site on Handsworth Heath in 1761 that

had a water-driven mill and cottage. By 1766, the mill had been replaced by a new factory, the Soho Manufactory designed by William Wyatt, and the cottage replaced by Matthew Boulton's home, Soho House, which he continued to develop.

The Soho Manufactory was both the largest and most modern factory of its day. Boulton was a producer of 'toys', which were small items such as buttons, badges, ornaments, silverware, buckles and coins when he built the Soho Mint on the same site. Very much the entrepreneur, he manufactured a vast range of consumer items employing pioneering mass-production techniques. When James Watt joined Matthew Boulton at the Soho Manufactory in 1774 the great partnership of the Industrial Revolution was forged a year later. The transition from pumping to rotational power that Boulton and Watt achieved with William Murdoch meant that machinery could for the first time be powered by steam. The Soho Foundry at Smethwick which they opened in 1796 with their sons was the world's first dedicated steam engine works.

Nothing now remains of the Soho Manufactory or Soho Mint, although small-scale excavations in 1994 did reveal some of the foundations. Soho House is now a museum dedicated to Matthew Boulton and the Lunar Society. Smethwick Soho Foundry, while not accessible to the public, will hopefully now be preserved.

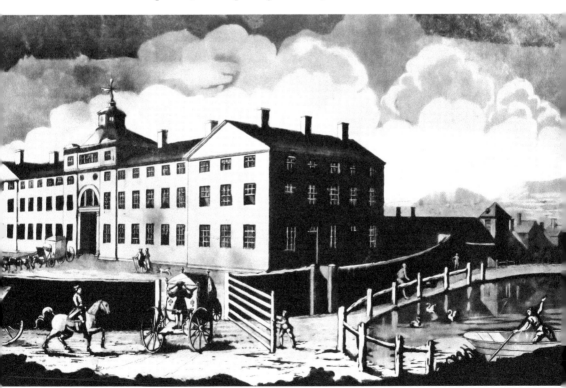

Matthew Boulton's Soho Manufactory. (Photo by Birmingham Museums Trust, licensed under CC0)

Tolkien and the Two Towers

J. R. R. Tolkien spent many years of his early life in Birmingham, which no doubt provided inspiration for his future books including The Lord of the Rings trilogy. Tolkien only spent a short time in Edgbaston, but could not fail to be intrigued by the close proximity of the Waterworks Tower and Perrott's Folly on Waterworks Road. The steam-powered water pumping station was built circa 1870 to a design by J. H. Chamberlain and W. Martin. Initially for the Birmingham Waterworks Company. It was purchased by Birmingham Corporation in 1876 under Joseph Chamberlain's 'gas and water socialism' initiative.

Below left: Edgbaston Waterworks Tower.

Below right: Perrott's Folly.

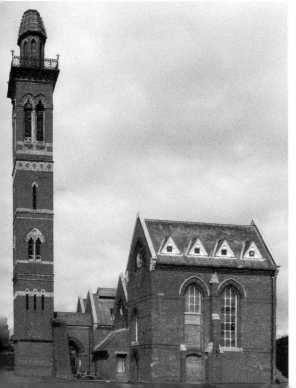

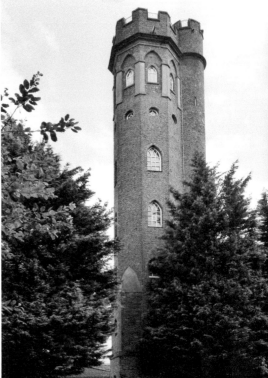

Nearby Perrott's Folly was built in 1758 by wealthy landowner John Perrott in Rotton Park. There are a number of local stories about why the tower was built, including spying on lovers or mistresses! More likely though it was built to let Perrott show off his estate to equally wealthy friends and acquaintances. One famous name later associated with the folly was Abraham Follett Ostler. He was the son of Thomas Ostler who had started the family glass business. It was Follett Ostler who designed the celebrated crystal fountain for the Great Exhibition of 1851. He was also a keen meteorologist and in conjunction with the Birmingham Midland Institute used Perrott's Folly as a weather observatory. These distinctive towers in such close proximity to each other may well have inspired Tolkien when he came to write part two of his Lord of the Rings trilogy, *The Two Towers*.

Thinktank, Birmingham Science Museum

Thinktank at Millennium Point opened in 2001 but many people still have fond memories of its predecessor, the Museum of Science and Industry in Newhall Street. This had been housed in the former Elkington Silver Electroplating Works. George Elkington and his cousin Henry opened the large factory in 1841 after patenting a successful silver-plating process. In 1842, they took on a third partner, founder of the Mason Science College, Josiah Mason. Fitting then that in 1951 the Museum of Science and Industry should open in the historic factory complex. There was always a sense of excitement exploring the many rooms and galleries in this veritable maze of a museum. It closed in 1997 and the exhibits were split between the new Thinktank and the Museum Collection Centre. This is Birmingham Museums' storage facility in Nechells. Although not open to the public on a daily basis visits can be booked in advance to see approximately 80 per cent of stored exhibits not on general display. Expect to find thousands of objects including steam engines, cars and countless fascinating artefacts.

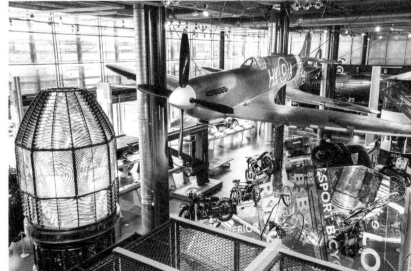

The Spitfire Gallery at Thinktank, Birmingham Science Museum. (Photo by Birmingham Museums Trust, licensed under CC0)

Thinktank, Birmingham Science Museum is set over four floors in the £114-million Millennium Point building on Curzon Street. Many of the displays are hands on and interactive covering the past, present and future of science and technology. Galleries hold exhibits such as the oldest working steam engine in the world, the 1799 Smethwick Engine, through to the outer reaches of space with Thinktank's own immersive Planetarium.

Town Hall

Opened in 1834, Birmingham Town Hall was designed by Joseph Aloysius Hansom and Edward Welch. Their design was based on the Roman Temple of Castor and Pollux. The enterprise bankrupted Hansom, but his name lives on as the inventor of the famous hansom cab. The original building was extended by architect Charles Edge in both 1837 and 1851.

The Grade I listed building developed an international reputation for music. The CBSO was based here until the opening of the orchestra's new home, Symphony Hall, in 1991. From classical to rock and pop, the Town Hall has hosted it all. Public readings were once popular and in 1853 the first reading of *A Christmas Carol* was given by Charles Dickens himself. He was raising money for the new Birmingham and Midland Institute. The Town Hall was also a centre for political speeches and debate.

In 1901, David Lloyd George was due to give a speech opposing the Boer War. This was right on Joseph Chamberlain's home ground, who supported the war as Colonial Secretary. Strength of feeling was such that a rioting mob formed, and Lloyd George was unable to deliver his address. Not only that, he came very close to being lynched and only managed to escape by being disguised as a policeman!

In the 1990s the building went into a decline and finally closed in 1996. Following extensive renovation, the Town Hall reopened in 2007 and remains one of Birmingham's most iconic buildings.

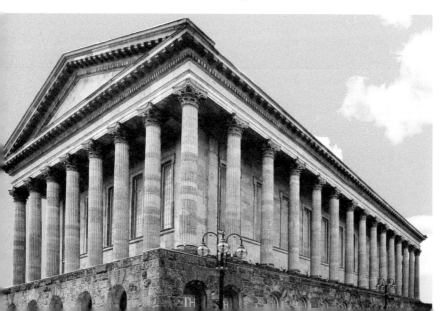

Birmingham Town Hall.

Trams

Together with canals and trains, Birmingham also had its trams. The first horse-drawn tramway of 1872 connected Hockley Brook through to Dudley Port. By 1882 Birmingham and Aston Tramways Company were running steam-driven trams, which would become widespread in Birmingham. Opening in 1888, a cable tramway operated between Colmore Row and Hockley Brook, later to be extended to Handsworth. This consisted of a continuously moving cable driven by a steam engine. Non-motorised trams would connect to the cable by a clamp operated by the driver. When the clamp was released a braking system would slow and stop the tram. Battery-powered trams followed, but the lead acid batteries proved unpopular with passengers due to the unpleasant fumes. By the early 1900s full electrification had been introduced using overhead wires.

The 1920s proved to be a golden age for trams in Birmingham, which would be replaced by motorbuses and trolleybuses, although the latter never had a major presence in Birmingham unlike Walsall and Wolverhampton and had disappeared by 1951. What was assumed to be the last Birmingham tram, No. 616 on Erdington Route 2, ran on 4 July 1953. Crowds lined the route to witness the end of an era. Recently though, trams have returned to Birmingham with the opening of the Midland Metro in 1999. Once again trams can be seen negotiating the streets between St Chads and Grand Central with an extension along Broad Street towards Edgbaston. Trams beyond New Street are again battery powered, but this time without the unpleasant fumes!

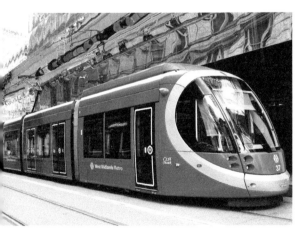

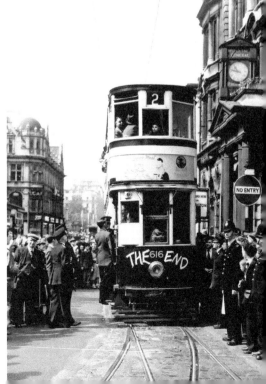

Above: New tram named after Birmingham's own Ozzy Osbourne.

Right: The last tram in 1953. (Contributor: Alamy Stock Photos)

Tyseley Locomotive Works

Great Western Railway's Tyseley shed started life in 1908 with two roundhouses and a substantial repair shop. Each roundhouse contained a 65-foot turntable with twenty-eight radiating tracks and inspection pits. By the end of 1968 the original roundhouses had gone and just one of the massive turntables remained. The future of steam at Tyseley was looking bleak until the coaling stage building became the 'temporary' home to 7029 Clun Castle, which had been purchased by the directors of the Dart Valley Railway. By 1967, 7029 Clun Castle Ltd had been formed and in 1968 the building was leased. Clun Castle had a new permanent home.

Other acquisitions followed including LMS Jubilee Class 5593 Kolhapur. As the collection increased the lease was extended, and a purpose-built workshop constructed. Tyseley now became Birmingham Railway Museum. The engineering facility took on much greater importance and a new company, the Tyseley Locomotive Works, was established. With the site now concentrating on railway engineering works and running regular mainline steam excursions, such as the popular Shakespeare Express under the separate company name of Vintage Trains, public access was restricted to open days.

Despite no longer being Birmingham Railway Museum, the site opens to the public on at least two weekends per year. These steam weekends draw enthusiasts from all over the country. A full-size live steam replica of Stephenson's Rocket is sometimes a feature of these events together with designer Robert Stephenson himself of course.

Earl of Mount Edgcumbe and Clun Castle at Tyseley Locomotive Works. (Contributor: Alamy Stock Photos)

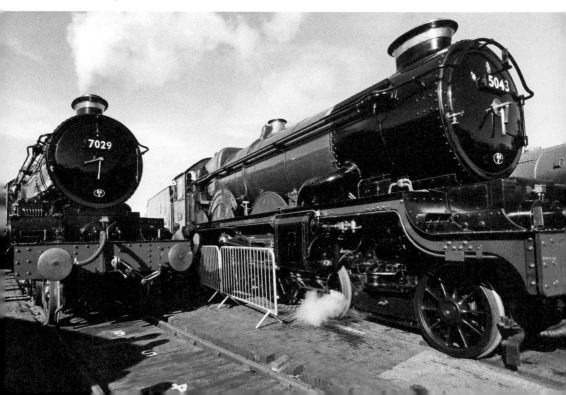

U

University of Birmingham

Birmingham has no fewer than five universities, including Aston, City, Newman, University College and the University of Birmingham. Most of these can trace roots back to Victorian education initiatives, but the University of Birmingham at Edgbaston was Britain's first non-denominational civic or 'red-brick' university. It received a royal charter from Queen Victoria in 1900, which awarded full university status.

The University of Birmingham grew out of an earlier medical school. As early as 1767 surgeon John Tomlinson was giving lectures on anatomy. By 1875, industrialist and philanthropist Josiah Mason had founded the Mason Science College, which opened to students on Edmund Street in 1880. This became Mason University College in 1898, which by then included the former Queen's College, a medical school originally founded in 1828 by William Sands Cox. The foundations for a University of Birmingham had been laid but it needed someone with vision and drive to see it achieved. That someone was politician and reformer Joseph Chamberlain.

A generous donation of land by the Calthorpe family saw the first phase of construction under architect Sir Aston Webb completed by 1909. The original red-brick buildings around Chancellor's Court included the tallest free-standing clock tower in the world at 325 feet, fittingly nicknamed 'Old Joe' after Joseph Chamberlain. While the campus has expanded greatly since 1909, the last piece of Aston Webb's original semicircle of buildings is a relatively new addition with the opening of the Bramall Music Building in 2012. No doubt the university's first professor of music, Edward Elgar, would have approved.

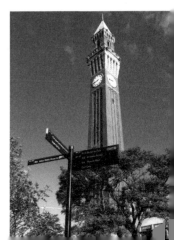

Joseph Chamberlain Memorial Clock Tower, 'Old Joe'.
(Contributor: Alamy Stock Photos)

Victoria Law Courts

Until Birmingham was granted an assize in 1884, major cases had to be heard at Warwick. Following a competition judged by celebrated architect, Alfred Waterhouse, Aston Webb and Ingress Bell of London won the commission to design the Victoria Law Courts. Aston Webb would later go on to design the Chancellor's Court at the new University of Birmingham. Queen Victoria was invited to lay the foundation stone in her Golden Jubilee year of 1887 and of course the building was named after her. Victoria Law Courts was officially opened by the Prince and Princess of Wales, later Edward VII and Queen Alexandra, in 1891.

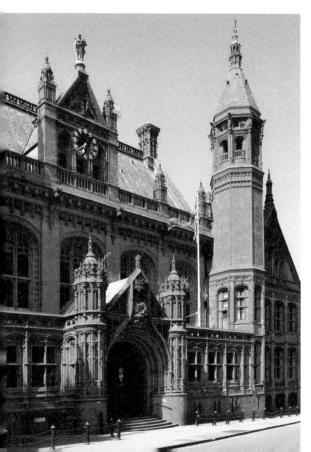

Victoria Law Courts.

The building was intended to make a bold statement about Birmingham's new city status. Built in red brick faced with deep red terracotta, detailed terracotta embellishments and a green stone tiled roof, the building easily justifies its Grade I listing. Inside is a magnificent Great Hall with crown chandeliers hanging from a massive hammer-beam timber roof. Sandy coloured terracotta is featured internally contrasting sharply with the imposing Judges' Courts, panelled in dark oak with oak canopies above the bench.

Opposite is the Grade II listed Methodist Central Hall of 1904 – also in red brick and terracotta. In an odd reversal of fortunes while the Central Hall was vacated by the Methodist Church in 1991 and no longer used for weddings, it is now possible to hire the Victoria Law Courts as a wedding venue.

Victoria Square House

By 1889, a number of buildings had been demolished to form a triangular space bordered by Pinfold Street, Hill Street and New Street. This was to enable the building

New General Post Office, New Street. (The British Library)

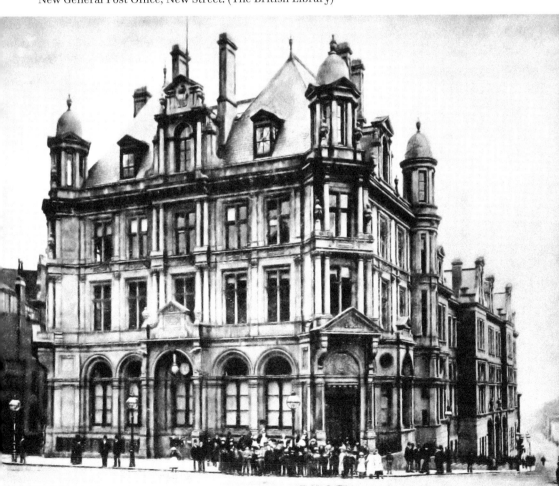

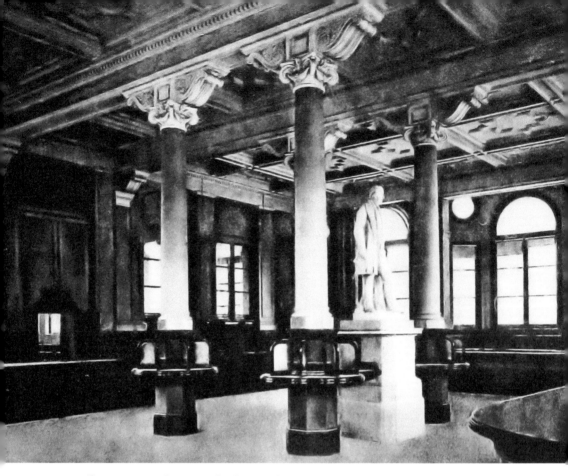

Post Office interior with statue of Roland Hill. (The British Library)

of a new General Post Office. The French Renaissance-style building, designed by Sir Henry Tanner of the Office of Works, opened on 23 December 1890. The spacious business hall featured a marble statue of Rowland Hill, the father of the modern postal system, by Birmingham sculptor Peter Hollins.

A contemporary description records that there were, 'lifts and subways for the conveyance of letters and parcels direct from the office to the railway platform'. This is one of Birmingham's hidden underground tunnels. A larger tunnel would later run from the Mailbox to New Street station when this was completed in 1970 to replace the old General Post Office. The iconic Mailbox building itself was sold in 1998 and is now an upmarket shopping, leisure, dining and commercial centre.

Like many of Birmingham's fine old buildings Victoria Square House, now Grade II listed, was scheduled for demolition in 1973. It was only due to the sterling efforts of the Birmingham Victorian Society supported by Pete Carter's Green Ban Action Committee that eventually saved it. In 1992 it became TSB's headquarters and it was they who commissioned Antony Gormley's *Iron: Man* statue. The building has had various tenants since then, but a Post Office branch is still attached to the original building.

W

Warstone Lane Cemetery

Warstone Lane, also known as Brookfields or Mint, is one of two Grade II listed cemeteries in the Jewellery Quarter. The other is Key Hill, opened in 1836, and mainly used by Nonconformists. The Church of England Cemetery Company was established in 1845 to provide a cemetery for Anglicans. It opened in 1848 on the site of an old sand pit, which gave rise to one of the cemetery's most unusual features. Two tiers of terraced catacombs were built into the sides of the old quarry.

Former Cemetery Lodge, Warstone Lane.

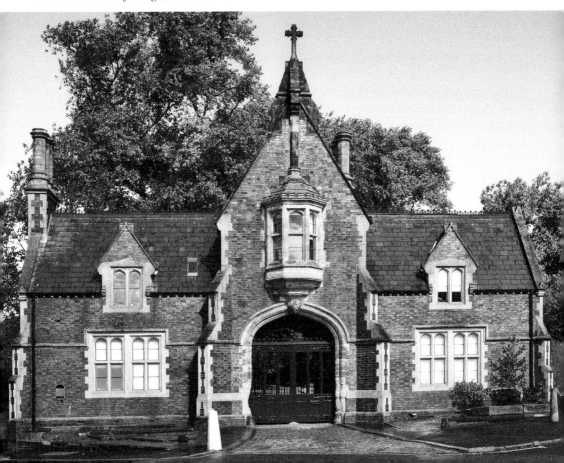

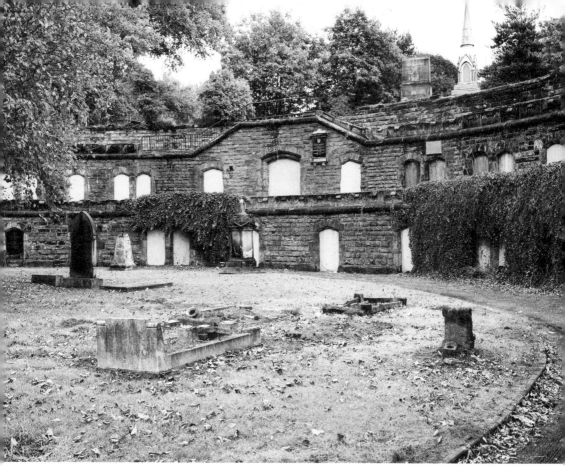

Warstone Lane Cemetery catacombs. (Contributor: Alamy Stock Photos)

This created a problem that led the 1846 Birmingham Cemeteries Act to require coffins in the catacombs to be sealed with lead or pitch. This was to stop the 'Unhealthy vapours and unpleasant smells emanating from them'. Above the catacombs was a Gothic-style chapel from which coffins could be lowered down. The chapel suffered severe bomb damage during the Blitz and was never repaired. It was demolished in the 1950s.

Printer John Baskerville, famed for his Baskerville typeface, was a committed atheist and left strict instructions not to be buried in consecrated ground. He was put to rest in the grounds of the original Baskerville House in a lead coffin, but later moved by workmen to Thomas Gibson's warehouse and his corpse was even put on show! After further moves and against his own wishes John Baskerville's final resting place was the catacombs.

To the left of the old Entrance Lodge (now offices) lies the stone that gave Warstone Lane its name. A large glacial stone known as an erratic, it was originally known as a 'hoar' or boundary stone and later corrupted to 'war-stone'. A voluntary group, Friends of Key Hill and Warstone Cemeteries, maintain the sites and run regular guided tours for members and visitors.

Weoley Castle

Weoley Castle is often described as being Birmingham's only castle. Despite the name it was only ever an imposing fortified medieval manor house. Once situated within a 1,000-acre deer park, it was originally a hunting lodge for the de Paganel and de Somery families and part of the Baronry of Dudley.

In 1264, Roger de Somery II obtained a licence from Henry III to crenellate (fortify) both Dudley Castle and the manor house at Weoley. It was known as Weoley Castle because it shared some features of a castle such as a moat, stone walls, battlements, gatehouse, great hall and a chapel. However, it lacked a keep and was not in a strong enough defensive position to be a viable castle.

On the death of John de Somery, Weoley Castle passed to his sister Joan and husband Thomas de Botetourt. From the early fifteenth century it was owned by the turbulent Berkeley family. Up until the early sixteenth century Weoley Castle was still home to the aristocracy until sold to London merchant, Richard Jervoise. He rented it to various tenants until the nineteenth century and during this time the buildings were increasingly used as farm buildings. By the eighteenth century stone from the now ruined castle was being used for canal bridges.

The Grade II listed ruins are some of the oldest in Birmingham and are a Scheduled Ancient Monument of national importance. Weoley Castle opens to the public for special events and guided tours throughout the year.

Weoley Castle ruins.

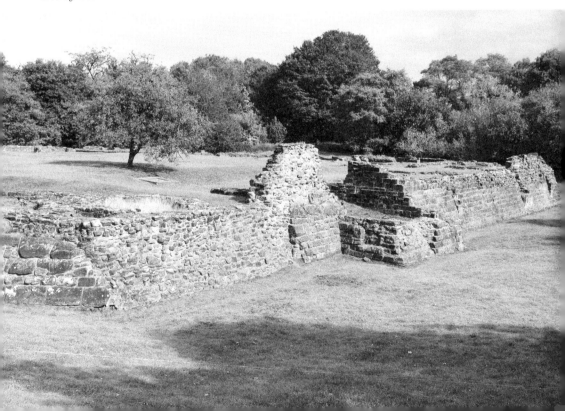

X-ray

A simple blue plaque on the wall of the Birmingham Children's Hospital records that 'Major Dr John Hall-Edwards Pioneer Radiologist worked here'. Born in 1858 at Kings Norton he studied medicine at Queen's College Birmingham, later Mason Science College, and qualified in 1885. Hall-Edwards was a keen amateur photographer and went on to become President of the Midland Photographic Club and an honorary member of the Royal Photographic Society.

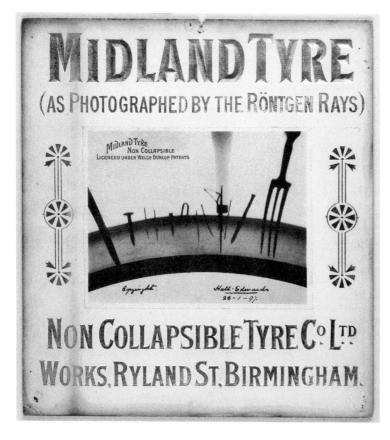

X-ray photograph by John Hall-Edwards, 1897. (Courtesy of Princeton University Art Museum)

Following Wilhelm Roentgen's discovery of X-rays in 1895, Hall-Edwards immediately saw the medical potential of the 'Roentgen' rays, as they were also known. He is credited with one of the first uses of X-rays under clinical conditions in January 1896 when he radiographed the hand of a colleague, clearly showing a sterilised needle beneath the skin. In February 1896 he took the first radiograph to direct a surgical operation. He was also the first to X-ray a human spine. In 1899 Hall-Edwards was appointed Surgeon Radiographer at the Birmingham General Hospital which eventually became the Children's Hospital. In 1900 he was also the first military radiographer, serving as a major in the Royal Army Medical Corps during the Boer War.

The pioneering work of John Hall-Edwards did not come without great personal cost. He lost his left arm to cancer, then called X-ray dermatitis, in 1908 and later four fingers of his right hand, eventually dying of cancer in 1926. His significant contribution to radiography was recognised in 1936 by inclusion on the Radiation Martyr's Memorial in Hamburg, Germany.

Yardley

Ancient Yardley was first mentioned in King Edgar's charter of 972 when it was known as Gyrdleahe and a possession of Pershore Abbey. The Domesday Book records it as 'Gerlei'. Old Yardley Village is a rare survivor of Birmingham's expansion into the suburbs and as such was designated a Conservation Area in 1969. Signs of medieval agriculture and later farm buildings lie in the vicinity of the thirteenth-century St Edburgha's Church. The church is dedicated to King Alfred's granddaughter, Edburgha, and gained its tower and spire in the fifteenth century. Next door to the church is the Old Grammar School (or Old Trust School). Dating to the late fifteenth century, this may have originally been a Guild Hall before it became a Trust School, which finally closed in 1908.

Another remarkable survivor is an Elizabethan yeoman's house. Now in the middle of a residential housing estate, Blakesley Hall was built circa 1590 by farmer and merchant Richard Smalbroke. The timber-framed building has been a museum since the 1930s. The house is furnished as it would have been in the seventeenth century and has a Tudor wall painting, which was only discovered following bomb damage during the Blitz. Blakesley Hall is also now home to the Gilbertstone, a massive stone (known as an erratic) that was carried into the Yardley area by an Ice Age glacier. Legend has it that a giant called Gilbert picked up and moved the huge stone to alter the boundary with his neighbour's land.

Below left: Blakesley Hall.

Below right: The Old Grammar School.

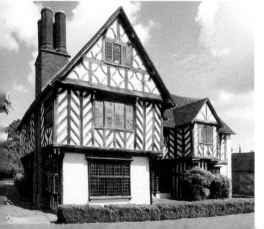
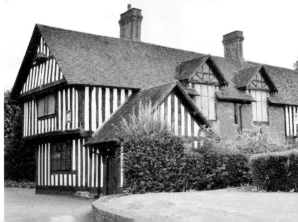

Z

Birmingham Zoo

Although relatively short lived, Birmingham Zoo was situated on the edge of Cannon Hill Park. The entrance building has served a number of purposes over the years and behind the present-day Birmingham Wildlife Conservation sign the word 'Museum' can be found carved into the masonry. Originally, the building was the Cannon Hill Museum, dedicated to the history of Birmingham, but in 1953 it became the National History Museum.

In 1963 Dudley Zoological Society submitted plans to Birmingham City Council to develop a 4-acre site on the edge of Cannon Hill park as a zoo. The site once housed a fulling mill known as Pebble Mill, which gave its name to the former BBC studios. The plans were accepted, and Birmingham Zoo opened on 1 May 1964. It housed mainly younger animals, monkeys, birds and camels for rides. The 1970 *Penguin Guide to British Zoos* described it as, 'a little gem of a zoo'.

The end for Birmingham Zoo came in 1973 after Birmingham City Council refused a request by Dudley Zoological Society to waive payment of the agreed 15 per cent of yearly ticket sales. After an initial surge of interest there were not enough visitors to give the society a profit after paying Birmingham their percentage. After closing as a zoo, the centre reopened in 1974 as the Birmingham Nature Centre. Still welcoming visitors, it is now known as the Birmingham Wildlife Conservation Park to reflect the conservation work now being undertaken.

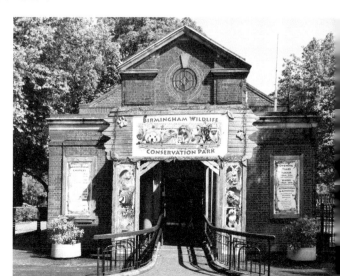

The former Birmingham Zoo.

Acknowledgements

I am very grateful to all the people and organisations who provided information, images and inspiration in the production of this book. Most are mentioned throughout the text, but special thanks are due to Ashley Dace for the Gun Barrel Proof House image, the Black Country Peakys together with Darren 'Slim' Butler and official photographer Stuart Lambeth, Martin Dighton 'Flyer1' for the Spitfire image and Steve Amos with James Perrins for the image of the two 'minis'. Particular thanks must also go to Birmingham Museums Trust and their Digital Image Resource, which has made so many wonderful historic images of Birmingham freely available under a Creative Commons licence.

About the Author

Andrew Homer has written several books on Birmingham and the Black Country and has an MA in West Midlands History awarded by the University of Birmingham. He presents lectures to various organisations and has appeared on local and national television. After a career as a college lecturer Andrew now works as a historic character at the Black Country Living Museum and can be found explaining the history of the region and the stories of the people who helped forge our industrial and social heritage.